Cool Hotels
London

teNeues

Imprint

Editor: Martin Nicholas Kunz

Editorial coordination & "What's special" texts: Susanne Olbrich

Photos (location): Courtesy Baglioni Hotel London; Gavin Jackson (base2stay, B+B Belgravia, Blakes London, Brown's Hotel, Claridge's, The Main House, Malmaison London); Roland Bauer (The Bentley Kempinski, Four Seasons Hotel Canary Wharf, Four Seasons Hotel Canary Wharf backcover on top); Roland Bauer, Barbara Kraft (Lobby image and backcover 3rd from top, One Aldwych); Roland Bauer, Courtesy Park Plaza Sherlock Holmes (Park Plaza Sherlock Holmes); Courtesy The Berkeley; Michelle Galindo (Bingham, Durley House, Kensington Rooms); Michelle Galindo, Courtesy Cadogan Hotel (photo 1 and backcover 2nd from top, Cadogan London); Courtesy Derby Hotels Collection (The Caesar), Courtesy Firmdale Hotels (Charlotte Street, Knightsbridge Hotel); Courtesy Courthouse Hotel Kempinski; Courtesy Hazlitt's; Courtesy High Road House (High Road House, backcover bottom); Courtesy The May Fair (The May Fair, backcover 4th from top); Courtesy Como Hotels & Resorts (Metropolitan London); Courtesy The Portobello Hotel; James Balston (The Rockwell); Courtesy The Rookery; Courtesy Eton Collection (Threadneedles); Andreas von Einsiedel (The Zetter)
Cover: Gavin Jackson (Blakes London)

Introduction: Bärbel Holzberg

Layout & Pre-press, Imaging: Jeremy Ellington

Translations: Alphagriese Fachübersetzungen, Dusseldorf

Produced by fusion publishing GmbH, Stuttgart . Los Angeles www.fusion-publishing.com

Price orientation: £ < 102 £ (150 €), ££ 103–190 £ (151–280 €), £££ 191–340 £ (281–500 €), ££££ > 340 £ (500 €)

Published by teNeues Publishing Group

teNeues Verlag GmbH + Co. KG	teNeues Publishing Company	teNeues Publishing UK Ltd.
Am Selder 37	16 West 22nd Street	P.O. Box 402
47906 Kempen, Germany	New York, NY 10010, USA	West Byfleet, KT14 7ZF
Tel.: 0049-(0)2152-916-0	Tel.: 001-212-627-9090	Great Britain
Fax: 0049-(0)2152-916-111	Fax: 001-212-627-9511	Tel.: 0044-1932-403509
E-mail: books@teneues.de		Fax: 0044-1932-403514

teNeues France S.A.R.L.
93, rue Bannier
45000 Orléans, France
Tel.: 0033-2-38541071
Fax: 0033-2-38625340

Press department: arehn@teneues.de
Phone: 0049-2152-916-202

www.teneues.com

ISBN: 978-3-8327-9206-0

© 2007 teNeues Verlag GmbH + Co. KG, Kempen

Printed in Italy

Bibliographic information published by Die Deutsche Bibliothek.
Die Deutsche Bibliothek lists this publication in the Deutsche Nationalbibliografie;
detailed bibliographic data is available in the Internet at http://dnb.ddb.de.

Contents

Page

Introduction 4

Baglioni Hotel London 10
base2stay 16
B+B Belgravia 20
The Bentley Kempinski 26
The Berkeley 32
Bingham 38
Blakes London 42
Brown's Hotel 48
Cadogan London 54
The Caesar 58
Charlotte Street 62
Claridge's 68
Courthouse Hotel Kempinski 76
Durley House 80
Four Seasons Hotel Canary Wharf 84
Hazlitt's 88
High Road House 92
Kensington Rooms 96
Knightsbridge Hotel 100
The Main House 104
Malmaison London 108
The May Fair 112
Metropolitan London 118
One Aldwych 122
Park Plaza Sherlock Holmes 126
The Portobello Hotel 130
The Rockwell 134
The Rookery 140
Threadneedles 144
The Zetter 148

Map 154
Cool Restaurants and Cool Shops nearby 156

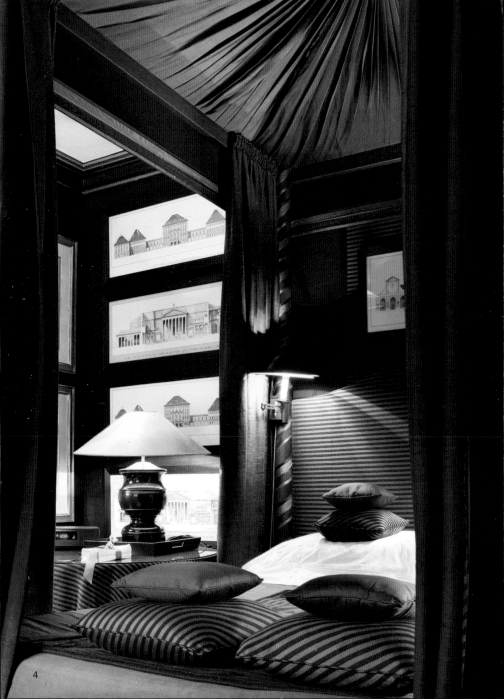

Introduction

A very special vibe distinguishes London. The metropolis attracts creative artists and ce-leb-rities from around the world, and the coolest fashion and music trends are born here. As a leading financial center, the City is a magnet for a tremendous amount of capital. This causes real-estate prices to shoot up into insane heights and the art market to explode. Nevertheless, what gives London its very unique appeal is the easy juxtaposition of the traditional British and the hip.

This variety can be optimally experienced at the hotels presented in this guide. Tim and Kit Kemp, owners of Firmdale Hotels, have turned the fact that each part of the city has its own particular character into the basic idea of their hotels. The casual bohemian chic of the Bloomsbury Group around Virginia Woolf is cultivated at their *Charlotte Street*. When you sit in front of the fireplace in the drawing room of the *Knightsbridge Hotel*, you will feel like you are a guest visiting good friends in their distinguished London town-house. In East London, warehouses and industrial factories have been converted into lofts that house artists'

studios and galleries. *The Zetter* in the newly fashionable Clerkenwell consistently picks up the loft theme with its rooms that are flooded in light and fresh air. With her subtle renovation of the *Brown's Hotel* in refined Mayfair, where London is most expensive, Olga Polizzi has brought back a London institution.

And there is good news for all those who have a budget more limited than their upmarket taste. The city's latest trend is reasonably priced, stylish bed & breakfast in the best locations, such as *base2stay* or *Kensington Rooms*. Their unpretentious names already signal that the establishments focus on the essential services—so don't expect limousine transfers or 24-hour room service.

You will find the entire range of the best London hotels in this guide: legendary grand hotels next to the addresses that are hip and styled down to the last detail, as well as the insider tips that alone make a stay in the metropolis on the Thames unforgettable.

Bärbel Holzberg

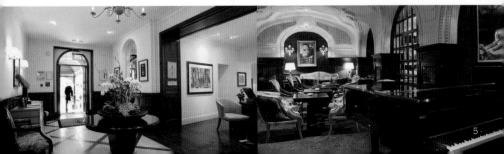

Einleitung

Es ist dieser ganz spezielle Vibe, den London auszeichnet. Die Metropole zieht Kreative und Celebrities aus aller Welt an, die coolsten Mode- und Musiktrends werden hier geboren. Als führender Finanzplatz spült die City ein ungeheures Kapital in die Stadt, lässt die Immobilienpreise in aberwitzige Höhen schnellen und den Kunstmarkt explodieren. Was London indes seinen einzigartigen Reiz verleiht ist das verträgliche Nebeneinander von traditionell Britischem und Hippem.

Die Vielfalt lässt sich bestens in den Hotels erleben, die dieser Führer vorstellt. Dass jeder Stadtteil seinen besonderen Charakter hat, haben Tim und Kit Kemp, Besitzer der Firmdale Hotels, zur Grundidee ihrer Hotels gemacht. Ihr *Charlotte Street* kultiviert den lässigen Bohemien-Chic der Bloomsbury Group um Virginia Woolf, vorm Kaminfeuer im Drawing Room des *Knightsbridge Hotel* fühlt man sich, als ob man zu Gast bei guten Freunden in ihrem feinen Londoner Townhouse sei. In East London wurden Lagerhäuser und Industrieanlagen zu Lofts umgebaut, die Künstlerateliers und Galerien beherbergen. *The Zetter* im neuerlich angesagten Clerkenwell greift mit seinen licht- und luftdurchfluteten Räumen konsequent das Loft-Thema auf. Im feinen Mayfair, wo London am teuersten ist, hat Olga Polizzi mit ihrer subtilen Renovierung des *Brown's Hotel* eine Londoner Institution wiederbelebt.

Und das ist eine gute Nachricht für alle, deren Budget begrenzter ist als ihr anspruchsvoller Geschmack. Neuester Trend in der Stadt sind stylische Bed & Breakfasts in bester Lage und erschwinglich wie das *base2stay* oder *Kensington Rooms*. Deren unpreziöse Namen signalisieren schon, dass man sich hier auf das Wesentliche konzentriert, also Limousinentransfers oder 24-Stunden-Roomservice eher nicht zu erwarten sind.

In diesem Guide finden Sie die ganze Palette der besten Londoner Hotels: legendäre Grandhotels neben durchgestalteten In-Adressen und Geheimtipps, die allein schon Ihren Aufenthalt in der Themse-Metropole zu einem unvergesslichen Erlebnis machen.

Bärbel Holzberg

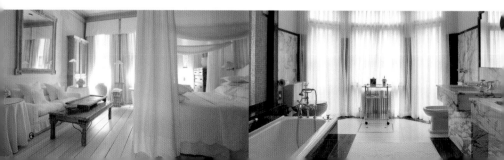

Introduction

C'est cette trépidation spéciale qui distingue Londres. La métropole attire des gens créatifs et des célébrités du monde entier. Les modes et les tendances musicales les plus cool sont nées ici. En tant que place financière dirigeante, la Cité renverse une capitale immense dans la ville, laisse les prix immobiliers faire un bond insensé et exploser le marché de l'art. Londres reconnaît cependant que son attrait particulier, c'est la coexistence accommodante du Britannique traditionnel et du branché.

La diversité de la ville se reflète parfaitement dans les hôtels représentés dans ce guide. Pour Tim et Kit Kemp, propriétaires des Firmdale Hotels, l'idée fondamentale de leurs hôtels, c'est que chaque quartier ait son caractère spécial. Leur *Charlotte Street* cultive le chic bohème insouciant du Bloomsbury Group, autour de Virginia Woolf, devant le feu de la cheminée dans le Drawing Room de *Knightsbridge Hotel* ; on se sent être un invité chez de bons amis dans leur maison de ville individuelle de Londres. Dans l'East London les entrepôts et les sites industriels ont été transformés en lofts qui abritent les ateliers d'artistes et les galeries. *The Zetter* dans le nouveau quartier à la mode de Clerkenwell, avec ses pièces baignées de lumière et d'air, reprend résolument le thème du loft. Dans le distingué Mayfair, où Londres est le plus cher, Olga Polizzi, avec sa subtile rénovation du *Brown's Hotel* a fait revivre une institution Londonienne.

Et cela est une bonne nouvelle pour ceux dont le budget est plus limité que son goût exigeant. La nouvelle tendance en ville ce sont les Bed & Breakfast stylés qui sont abordables et situés dans les meilleures sites comme le *base2stay* ou le *Kensington Rooms* dont les noms ordinaires signalent déjà que l'on se concentre sur l'essentiel ; par conséquent, il ne faut pas espérer des transferts en limousine ou des services hôteliers 24 heures sur 24.

Dans ce guide, vous trouverez toute la gamme des meilleurs hôtels Londoniens : les Grandhôtels légendaires ainsi que des adresses bien présentés et des tuyaux, qui, par eux-mêmes, vont transformer votre séjour dans la métropole au bord de la Tamise en une expérience inoubliable.

Bärbel Holzberg

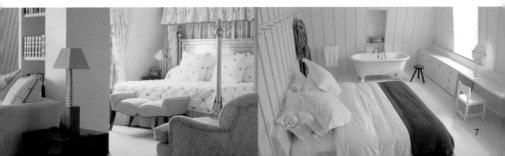

7

Introducción

Es su vibración especial lo que convierte Londres en algo excepcional. La metrópoli atrae creativos y famosos desde todo el mundo y hace nacer las tendencias musicales y de moda más cool. En su papel de máximo centro financiero, la City hace circular capitales impresionantes por la ciudad, empujando los precios de los inmuebles hacia un crecimiento descabellado y haciendo explotar el mercado del arte. Lo que confiere a Londres su encanto especial es la pacífica convivencia entre entre la tradición britana y el mundo de las últimas tendencias.

Esta variedad se deja experimentar por completo en los hoteles presentados por esta guía. El hecho de que cada uno de los barrios de la ciudad posea su propio carácter peculiar ha sido adoptado por Tim y Kit Kemp, propietarios de la sociedad Firmdale Hotels, como idea fundamental para sus hoteles. Su *Charlotte Street* cultiva el chic bohemio del Bloomsbury Group alrededor de Virginia Woolf, mientras que en el *Knightsbridge Hotel* el fuego de la chimenea en el Drawing Room nos hace sentir huéspedes entre buenos amigos en una refinada casa de ciudad londinense. En East London los depósitos y las naves industriales se transforman en loft y acogen talleres y galerías de arte. En Clerkenwell, zona de las tendencias más recientes, *The Zetter* captura perfectamente el espíritu del loft, con sus espacios inundados por la luz y el aire. En el refinado Mayfair, en lo más caro de toda Londres, Olga Polizzi ha devuelto al *Brown's Hotel* su estatus de institución londinense, gracias a su sutil renovación.

Y esta es una buena noticia para todos quienes pongan sus presupuestos a los mismos niveles de sus exigentes gustos. La última tendencia de la ciudad son los característicos bed & breakfast en posiciones óptimas y precios razonables, como el *base2stay* o el *Kensington Rooms*, cuyos nombres poco presumidos ya anuncian que la atención está puesta sobre lo esencial y, por lo tanto, no hay que esperarse servicios de limusina o de habitación las 24 horas.

En la presente guía se encuentra la entera colección de los mejores hoteles de Londres: Grandes Hoteles legendarios al lado de casas acondicionadas según las últimas modas y nombres casi desconocidos, que ya de por si mismos convertirán su estancia en la metrópoli sobre el Támesis en una experiencia inolvidable.

<div align="right">

Bärbel Holzberg

</div>

Introduzione

È la sua vibrazione speciale che fa di Londra qualcosa di eccezionale. La metropoli attira creativi e celebrità dal mondo intero, ed è qui che nascono le tendenze musicali e le mode più cool. Nel suo ruolo di preminente centro finanziario, la City fa circolare una formidabile quantità di capitale in città, spingendo in folle ascesa i prezzi degli immobili e facendo esplodere il mercato dell'arte. Allo stesso tempo, è la pacifica convivenza fra la tradizione britannica e le ultimissime tendenze che conferisce a Londra il suo fascino particolare.

Questa varietà si sperimenta al meglio negli hotel proposti nella presente guida. Il fatto che ogni quartiere possieda il proprio carattere unico è stato accolto da Tim e Kit Kemp, titolari della compagnia Firmdale Hotels, che ne hanno fatto il concetto fondamentale per i loro hotel. Il loro *Charlotte Street* coltiva il languido chic bohémien alla Bloomsbury Group attorno a Virginia Woolf, mentre nel *Knightsbridge Hotel* l'ospite si accomoda al fuoco del caminetto nella Drawing Room, come se fosse ospite di buoni amici nella loro raffinata casa di città londinese. A East London i magazzini e gli stabilimenti industriali vengono rimodellati in loft e accolgono atelier artistici e gallerie. *The Zetter* a Clerkenwell, la più recente area di tendenza, riprende e rilancia lo spirito del loft, con i suoi spazi inondati di luce e d'aria. Nel raffinato Mayfair, dove Londra raggiunge l'apice in quanto a prezzi, il sottile rinnovamento di Olga Polizzi ha riportato il *Brown's Hotel* al livello di istituzione cittadina.

E questa è certamente una buona notizia per tutti coloro che dispongono di un budget e di un esigente buon gusto che vanno di pari passo. L'ultimo grido della città sono i caratteristici e curati bed & breakfast in posizione ideale e dai prezzi ragionevoli, ad esempio il *base2stay* o il *Kensington Rooms*, i cui nomi alla mano stanno già a indicare che qui ci si concentra sull'essenziale, e pertanto non ci si deve attendere limousine con autista o servizio in camera 24-su-24.

In questa guida troverete l'intera gamma dei migliori hotel di Londra: grand hotel leggendari così come alberghi plasmati secondo le ultime tendenze e ottimi consigli su nomi molto meno conosciuti, che già da soli trasformeranno la vostra permanenza nella metropoli sul Tamigi in un'esperienza indimenticabile.

Bärbel Holzberg

Baglioni Hotel London

60 Hyde Park Gate
Kensington
London, SW7 5BB
Phone: +44 20 7368 5700
Fax: +44 20 7368 5701
www.baglionihotels.com

Cool Restaurants nearby:
Fifth Floor
The Admiral Codrington

Cool Shops nearby:
Alberta Ferretti
Allegra Hicks
Dolce & Gabbana

Price category: ££££
Rooms: 18 rooms, 34 junior suites and 15 suites
Facilities: Restaurant
Services: Butler, VIP Maserati courtesy car service
Located: Opposite Kensington Palace
Tube: High Street Kensington
Map: No. 1
Style: Contemporary design
What's special: A prestigious 5-star hotel, an exclusive shelter, both cosy and reserved; a fine example of Italian Stile di Vita.

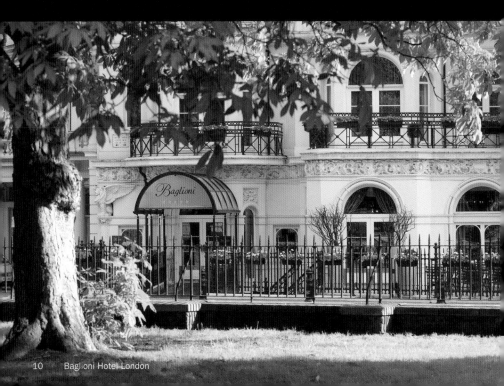

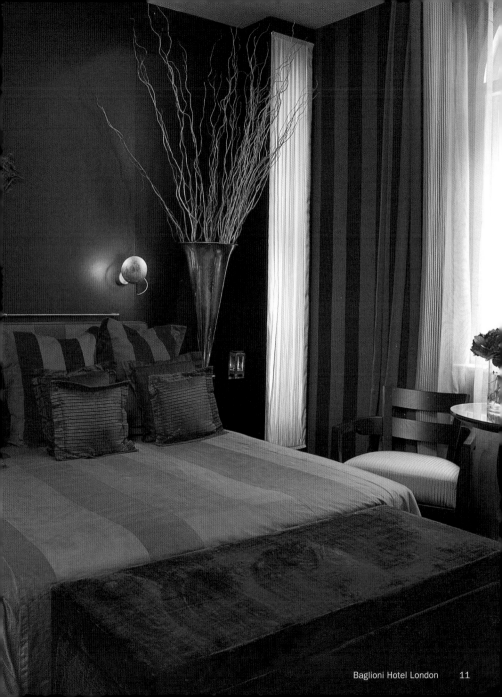

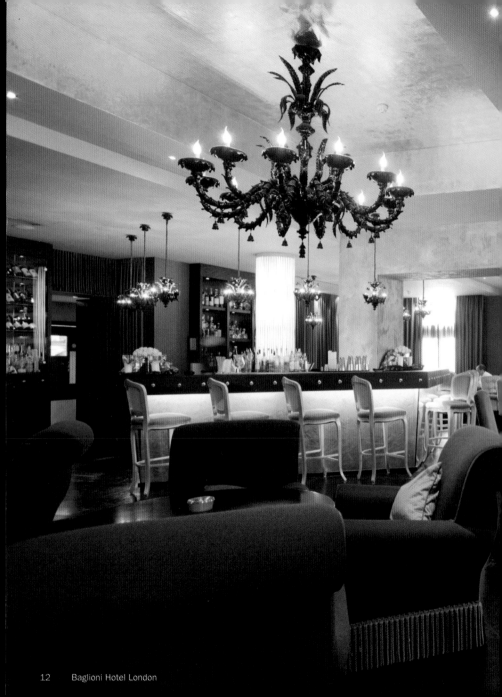

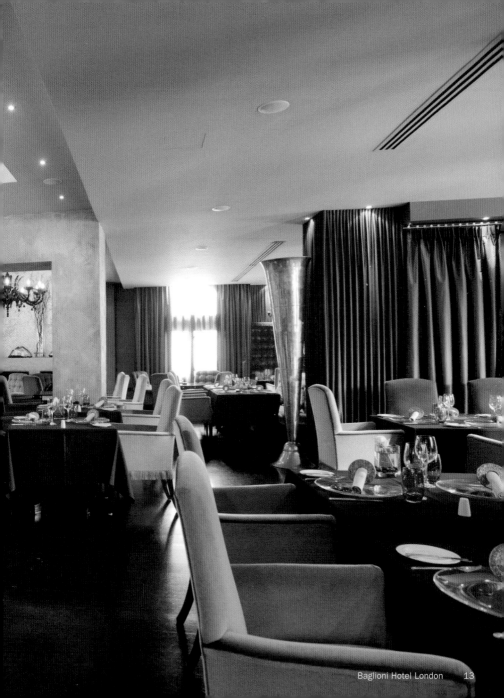

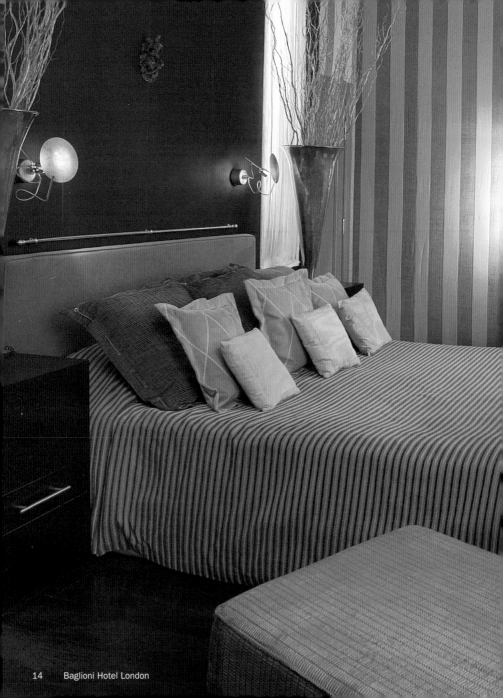

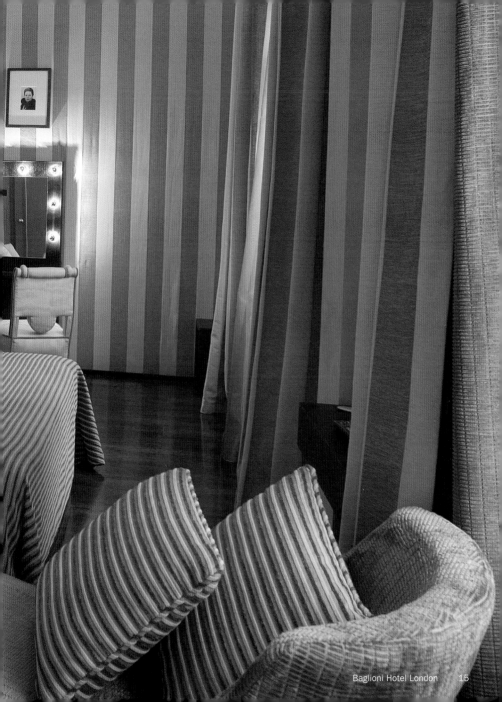

base2stay

25 Courtfield Gardens
Kensington
London, SW5 0PG
Phone: +44 845 262 8000
Fax: +44 845 262 8001
www.base2stay.com

Cool Restaurants nearby:
Fifth Floor
The Admiral Codrington

Cool Shops nearby:
Diesel
Espacio
Poliform

Price category: £
Rooms: 67 rooms
Services: Mini kitchen in all rooms, free internet access
Located: In South Kensington
Tube: Earl's Court, Gloucester Road
Map: No. 2
Style: Contemporary design
What's special: The new "edited service" approach, offering a synthesis of London boutique and budget hotels with serviced apartments for today's design conscious, value-orientated guest.

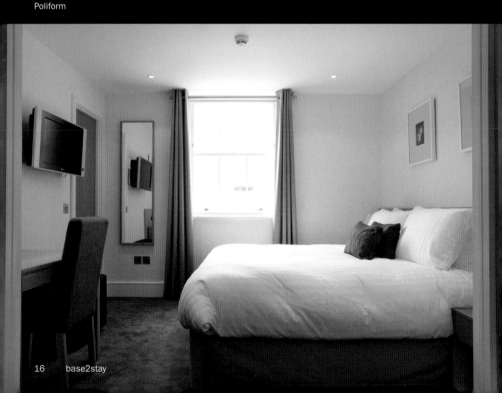

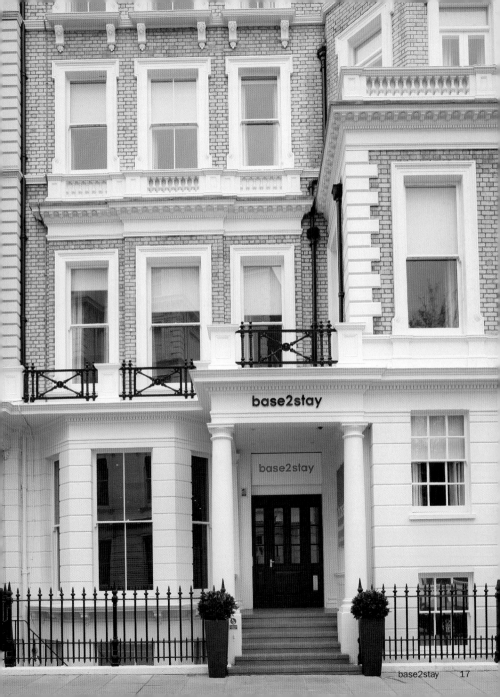

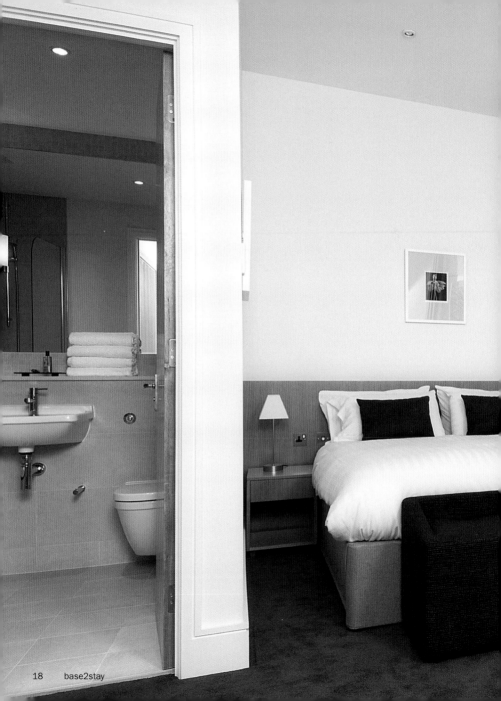

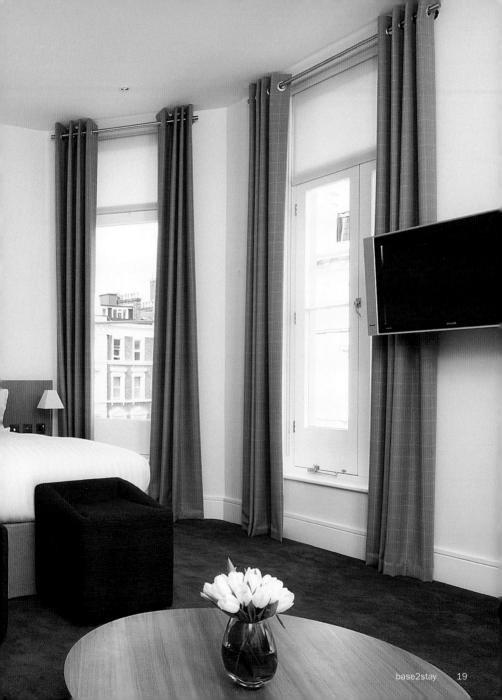

64–66 Ebury Street
Belgravia
London, SW1W 9QD
Phone: +44 20 7259 8570
Fax: +44 20 7259 8591
www.bb-belgravia.com

Cool Restaurants nearby:
Boxwood Café
Fifth Floor
Pétrus

Cool Shops nearby:
Allegra Hicks
Michel Guillon
Tateossian London

Price category: £
Rooms: 17
Services: Free internet access, free complimentary fresh teas and coffees—including cappuccino—24-hours daily, free bikes to borrow
Located: 5 minutes walk from Victoria Mainline Station
Tube: Victoria
Map: No. 3
Style: Contemporary design
What's special: The contemporary interior design and state of the art technology combine to make an inviting, modern and comfortable environment—a refreshing new B+B concept where you can really feel "at home."

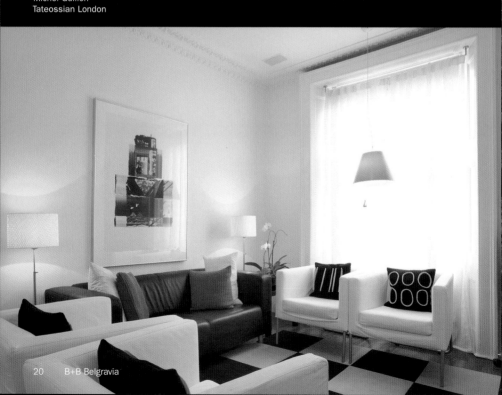

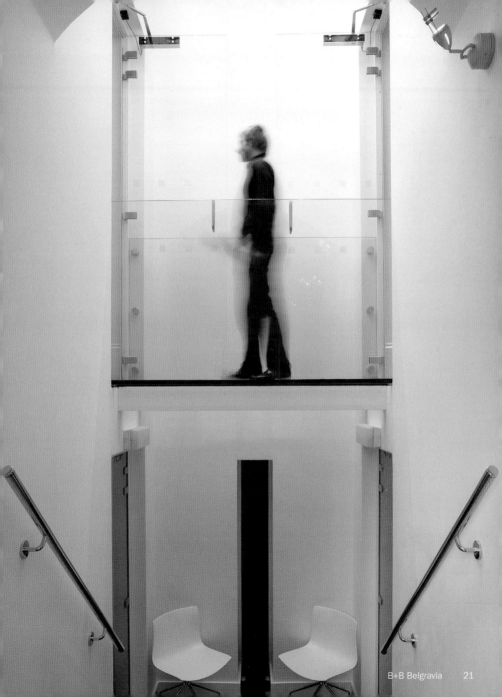

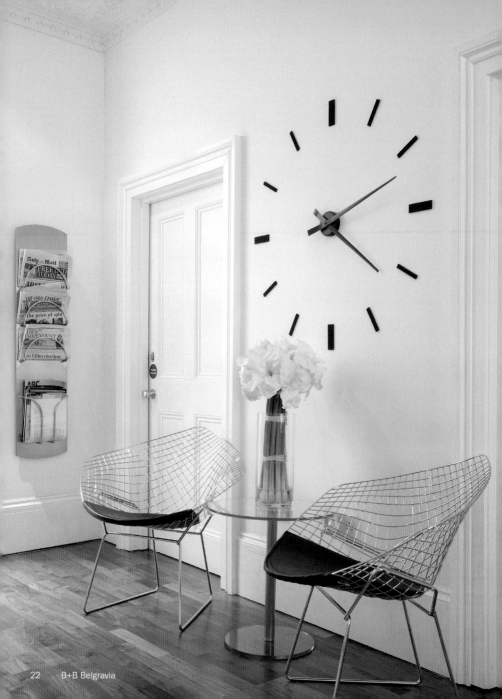

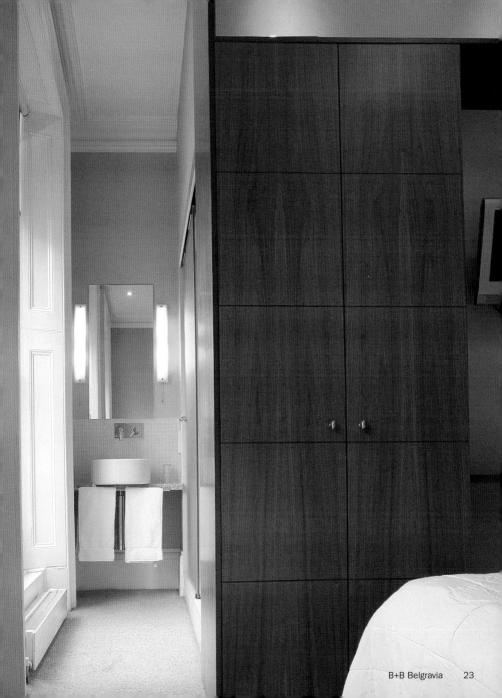

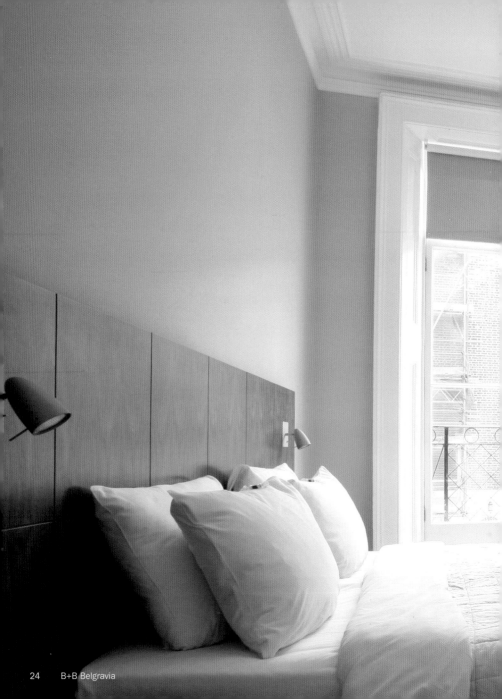

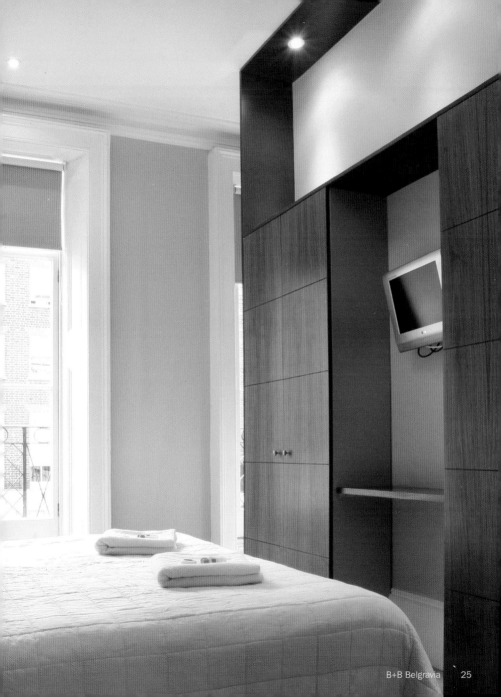

The Bentley Kempinski

Harrington Gardens
South Kensington
London, SW7 4JX
Phone: +44 20 7244 5555
Fax: +44 20 7244 5566
www.thebentley-hotel.com

Cool Restaurants nearby:
Fifth Floor
The Admiral Codrington

Cool Shops nearby:
Diesel
Espacio
Poliform

Price category: ££££
Rooms: 39 rooms and 25 suites
Facilities: Restaurants 1880 & Peridot, Malachite bar, The Cigar Divan, Le Kalon Spa
Services: Private butler on request, 24-hour in room dining, private dining and events, licensed for weddings
Located: A stroll to Knightsbridge's world famous Harrods
Tube: Gloucester Road
Map: No. 4
Style: Classic elegance
What's special: One of London's best kept secrets. The hotel is discreetly hidden in a residential area, providing that feeling of being home from home. The grand, white façade, the opulent and luxurious design, everything points to a 5-star hotel.

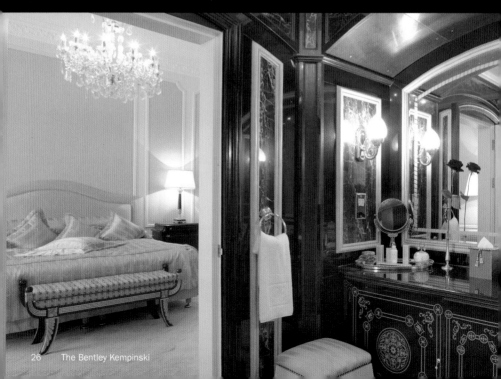

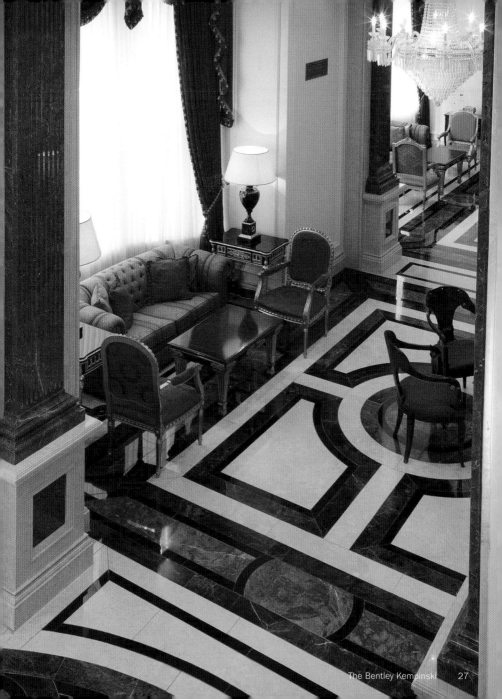

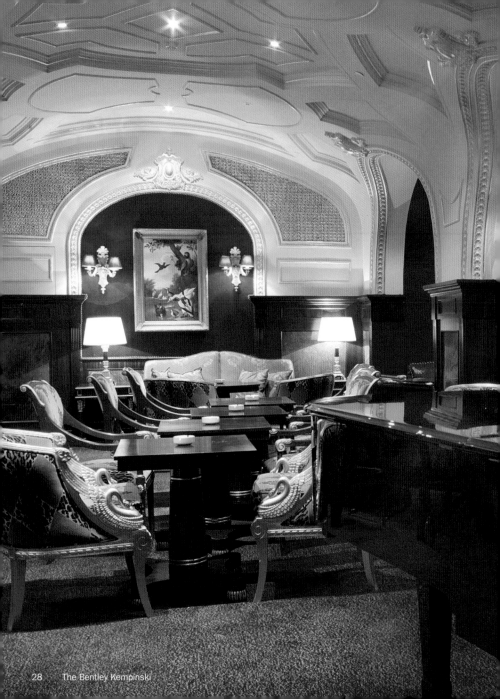

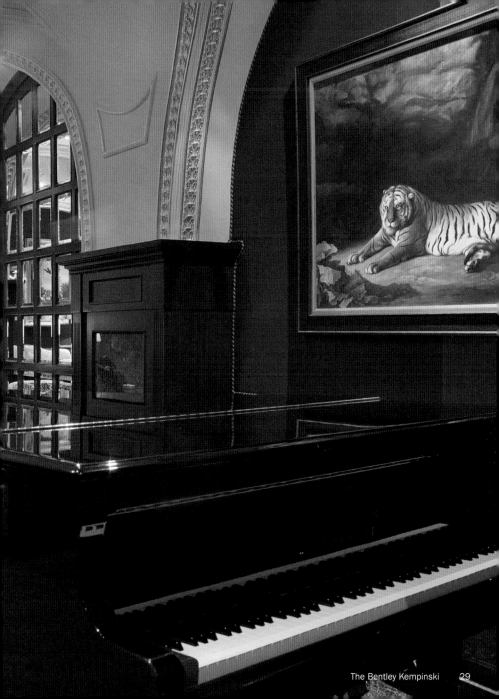

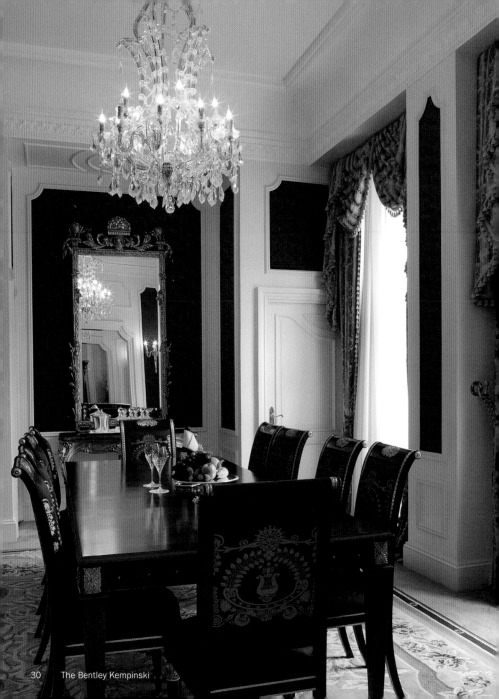

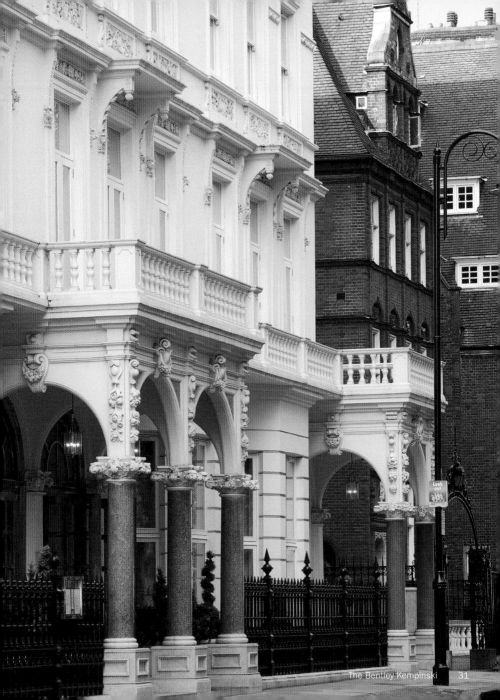

The Berkeley

Wilton Place
Knightsbridge
London, SW1X 7RL
Phone: +44 20 7235 6000
Fax: +44 20 7235 4330
www.the-berkeley.co.uk

Cool Restaurants nearby:
Pétrus
Boxwood Café

Cool Shops nearby:
Alberta Ferretti
Miller Harris
Stella McCartney

Price category: ££££
Rooms: 214 rooms including 61 suites
Facilities: 3 restaurants, The Blue Bar, swimming-pool with panoramic views over Knightsbridge
Services: "Prêt-à-Porter: a Fashionista's Afternoon Tea," babysitting or child minding services, personal trainer
Located: Opposite Hyde Park and within easy reach of Knightsbridge's famous stores
Tube: Hyde Park Corner, Knightsbridge
Map: No. 5
Style: Classic elegance
What's special: It has retained its elegance with the people of the time favored by celebrities. Gordon Ramsay's Boxwood Café and Marcus Wareing's Pétrus have secured it as one of the world's leading gastronomic hotels.

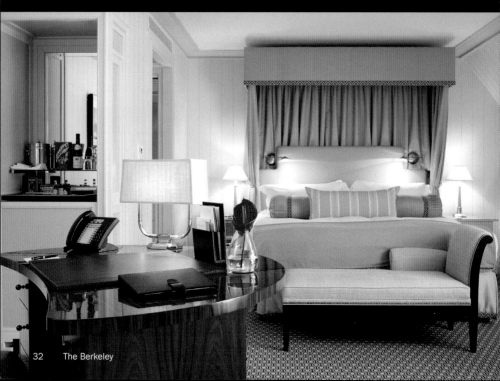

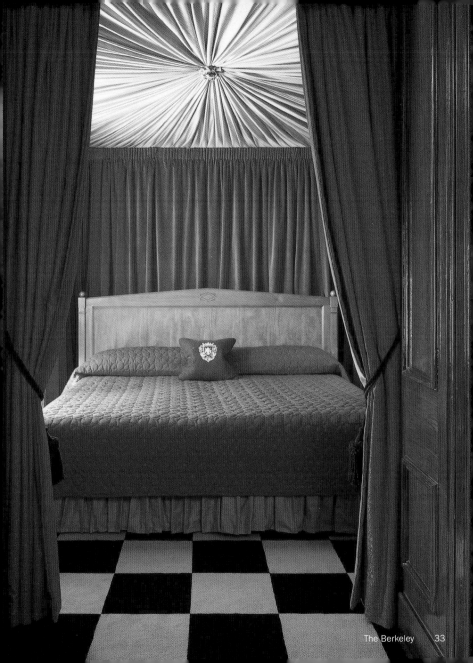

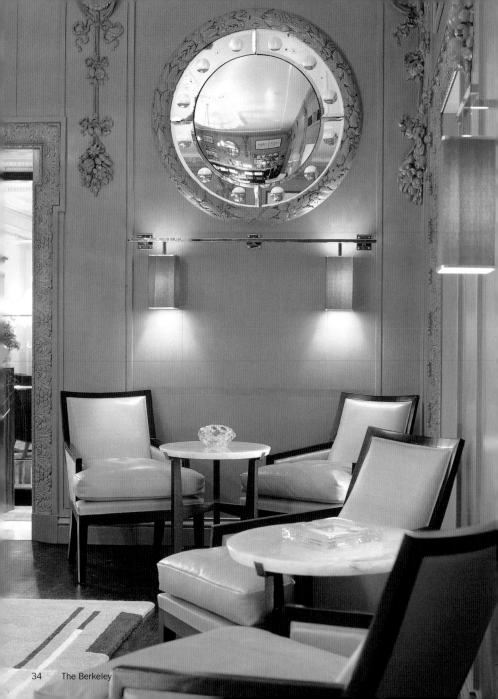

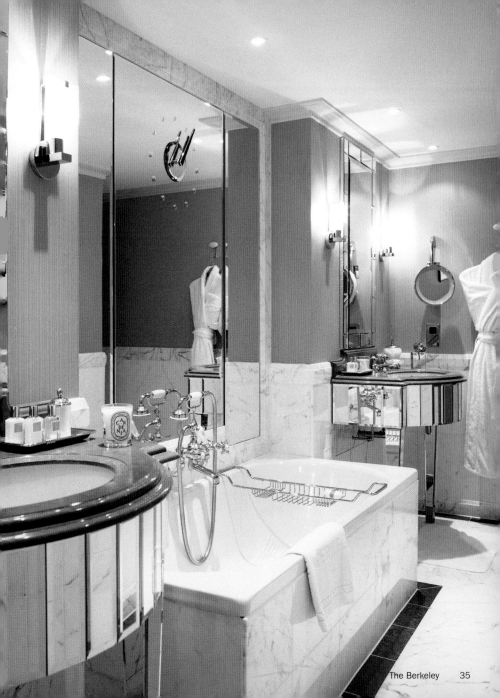

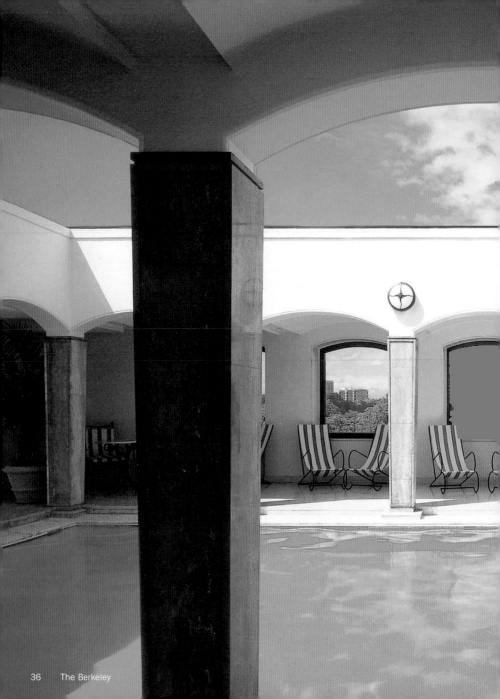

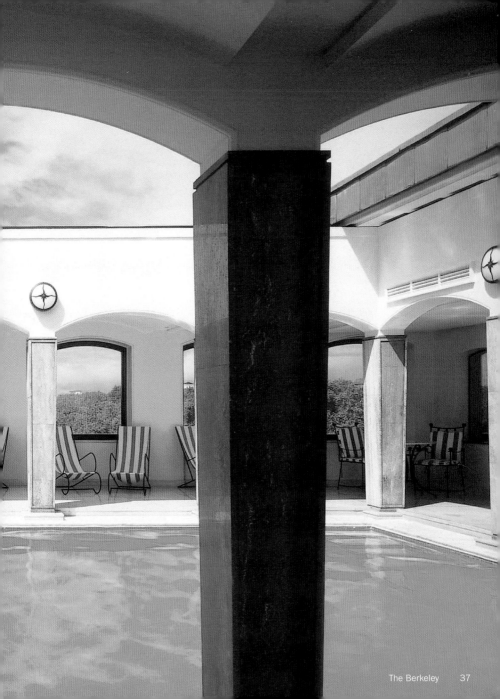

Bingham

61–63 Petersham Road
Richmond upon Thames
Surrey, TW10 6UT
Phone: +44 20 8940 0902
Fax: +44 20 8948 8737
www.thebingham.co.uk

Price category: ££
Rooms: 15
Facilities: Restaurant, lounge bar and private garden, rooms for event hire
Services: Live jazz Sunday afternoons, wedding services
Located: In Richmond and still close to London's West End
Tube: Richmond
Map: No. 6
Style: Intimate and elegant
What's special: A boutique style hotel portraying contemporary luxury in the confines of a Georgian townhouse dating back to the 1700's. Alfresco dining on a heated balcony overlooking the River Thames, and 3 Garden Rooms for events and weddings with access to a private terrace and landscaped gardens.

Cool Restaurants nearby:
The Glasshouse
The River Café

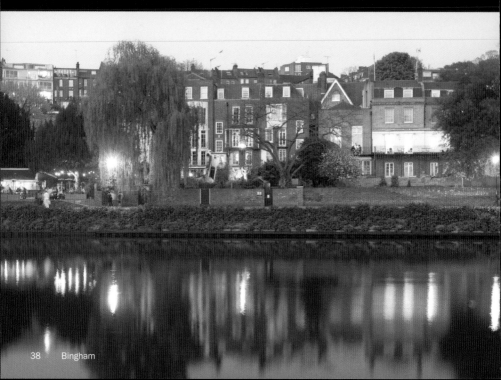

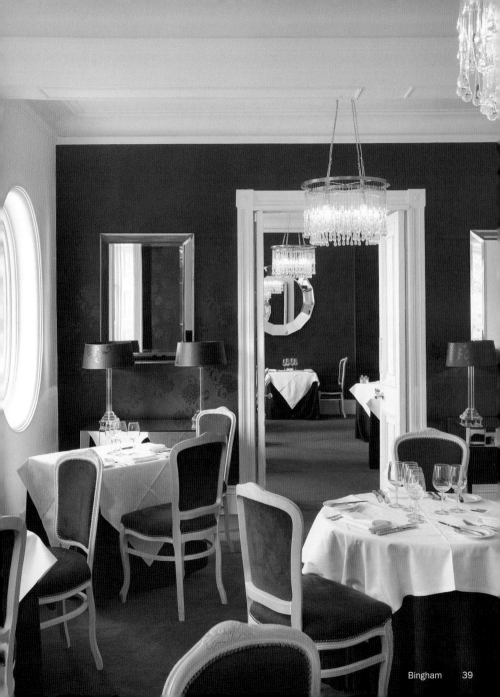

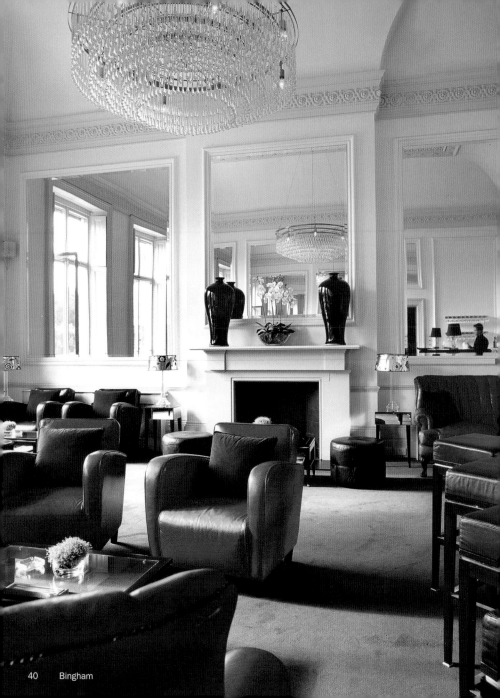

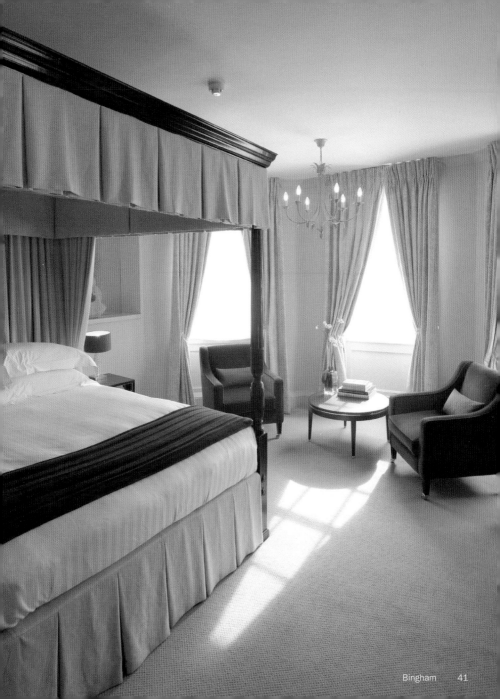

Blakes London

33 Roland Gardens
South Kensington
London, SW7 3PF
Phone: +44 20 7370 6701
Fax: +44 20 7373 0442
www.blakeshotels.com
www.anouskahempeldesign.com

Cool Restaurants nearby:
The Admiral Codrington
The River Café

Cool Shops nearby:
Diesel
Espacio
Poliform

Price category: £££
Rooms: 48
Facilities: Restaurant, private meeting room
Services: Wedding ceremonies in Suite 007
Located: Just steps away from the fashionable Brompton Road and Harrods
Tube: Gloucester Road, South Kensington
Map: No. 7
Style: Contemporary design
What's special: Created by acclaimed British designer Anouska Hempel, the hotel is an architectural statement of uniqueness and originality—rooms are individually themed. It is established as the blueprint for the "fashionable small hotel" all around the world.

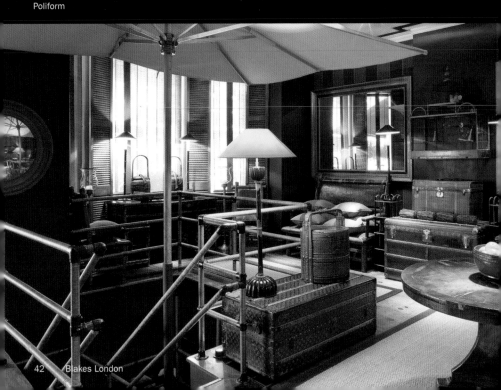

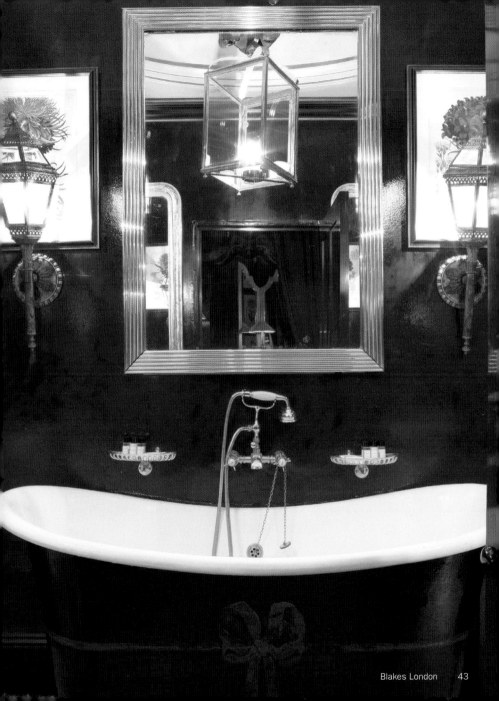

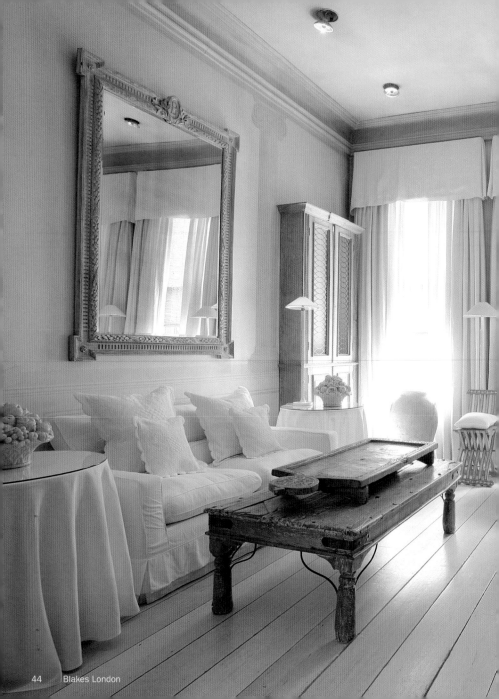

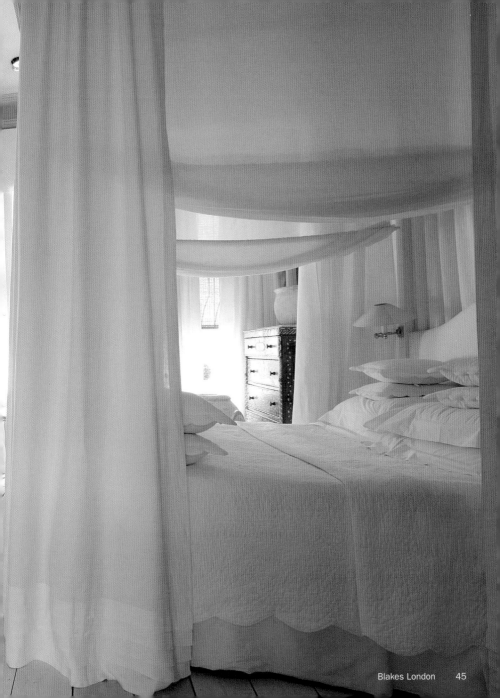

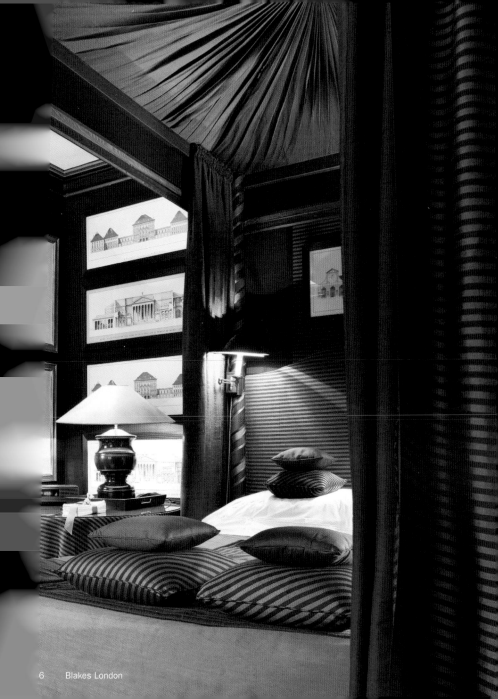

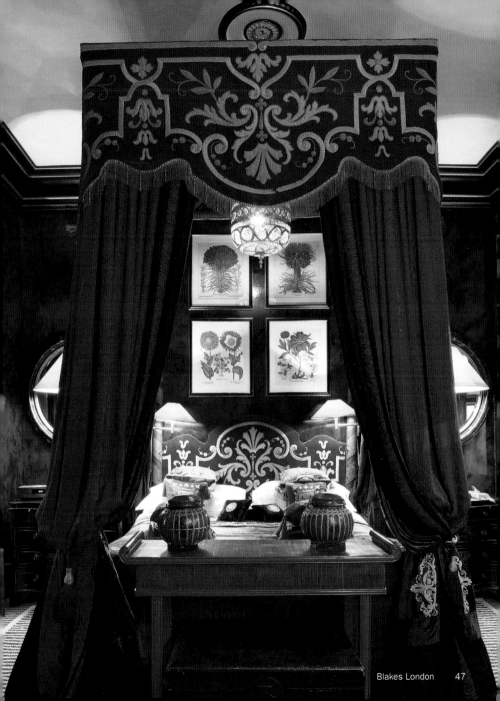

Brown's Hotel

Albemarle Street
Mayfair
London, W1S 4BP
Phone: +44 20 7493 6020
Fax: +44 20 7493 9381
www.roccofortehotels.com

Cool Restaurants nearby:
Automat
Nobu Berkeley
Umu

Cool Shops nearby:
Dover Street Market
Emanuel Ungaro
Erco

Price category: ££££
Rooms: 98 rooms and 19 suites
Facilities: Restaurant, tea room & bar, private dining rooms, 3 spa treatment rooms
Services: Wireless Internet available in public areas
Located: Just a few steps from Piccadilly and the elegant shops of Bond Street
Tube: Green Park, Piccadilly Circus
Map: No. 8
Style: Classic elegance
What's special: Sophistication and classic English style are the hallmarks of the most historic hotel in London. A long-held British institution: afternoon tea in the hotel's English Tea Room serving one of the best afternoon teas in London.

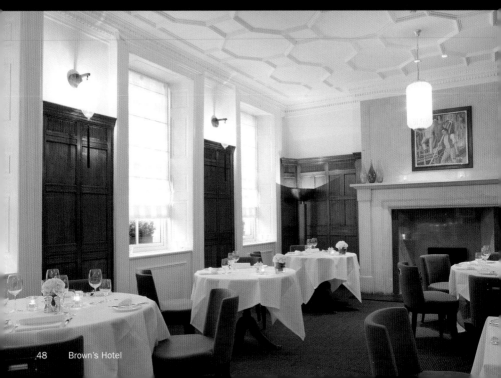

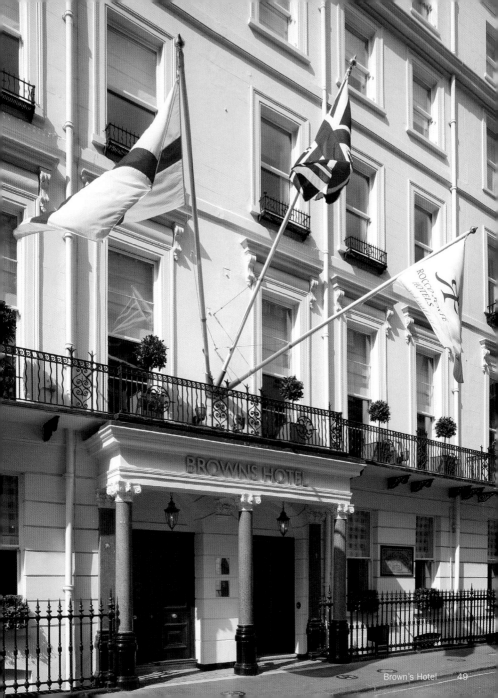

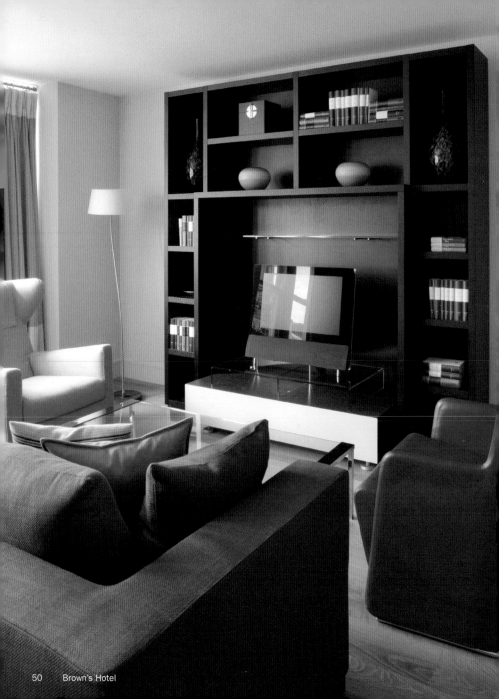

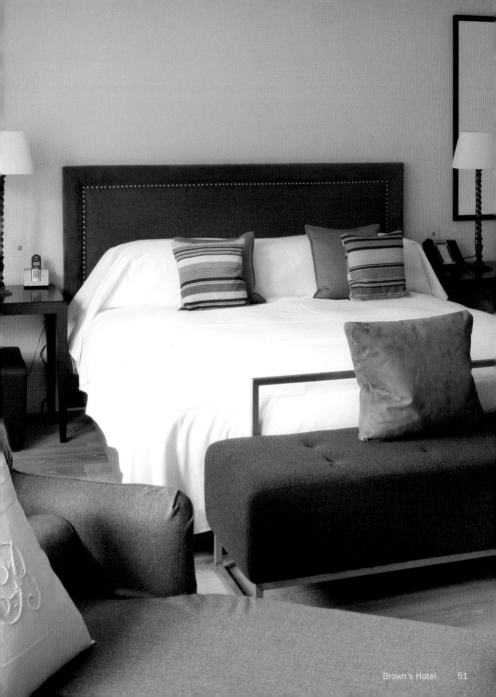

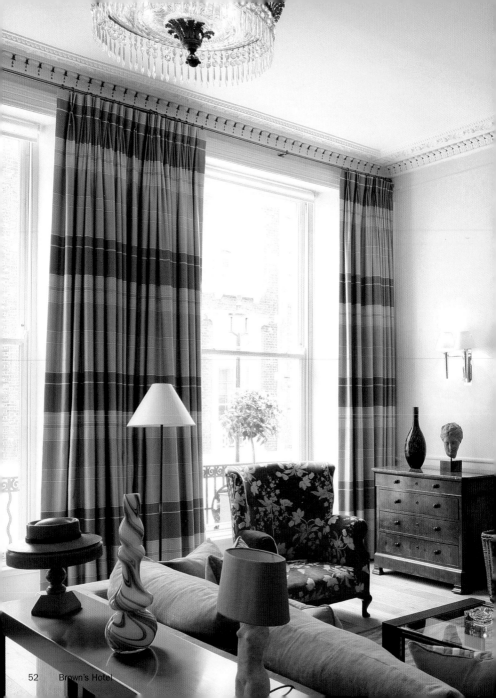

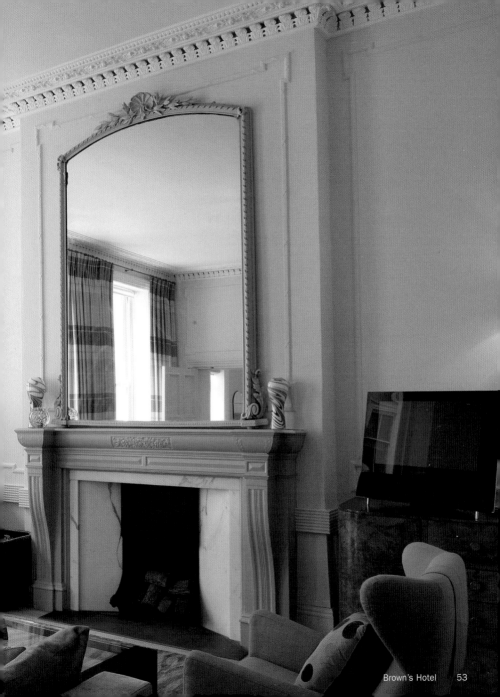

Cadogan London

75 Sloane Street
Knightsbridge
London, SW1X 9SG
Phone: +44 20 7235 7141
Fax: +44 20 7245 0994
www.steinhotels.com/cadogan

Cool Restaurants nearby:
Boxwood Café
Fifth Floor

Cool Shops nearby:
Alberta Ferretti
Allegra Hicks
Dolce & Gabbana

Price category: £££
Rooms: 65 rooms and suites
Facilities: Langtry's Restaurant, bar, gym
Services: Private dining, meetings, wedding services
Located: Between Knightsbridge and Sloane Square
Tube: Sloane Street
Map: No. 9
Style: Classic elegance
What's special: Built in 1887 reflecting timeless old-world elegance yet complemented by touches of unexpected modernity. History comes alive. Consider room 118, scene of the arrest of Oscar Wilde. The Cadogan is a Member of Stein Hotels and Resorts.

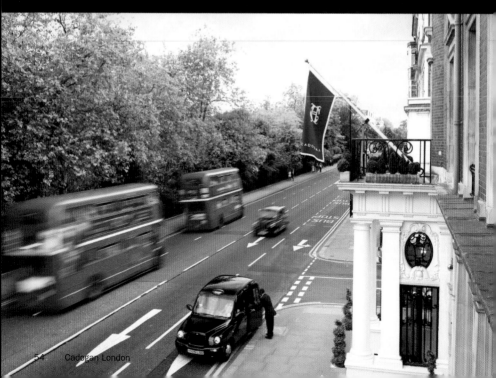

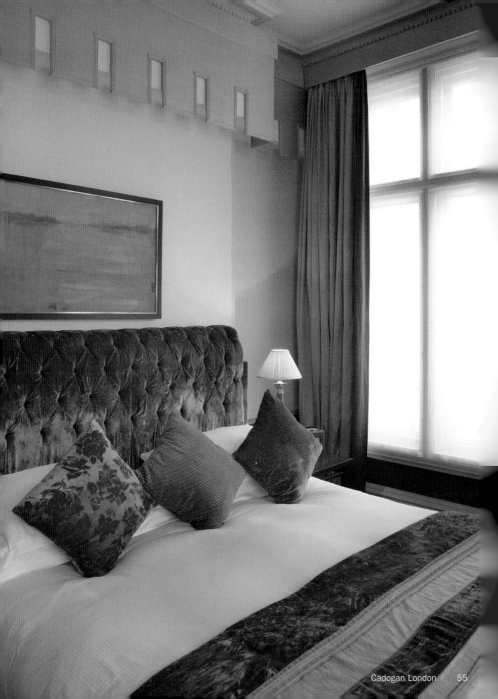

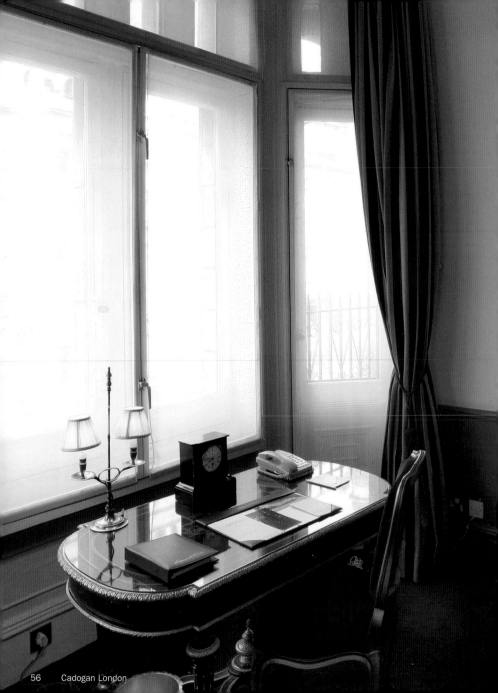

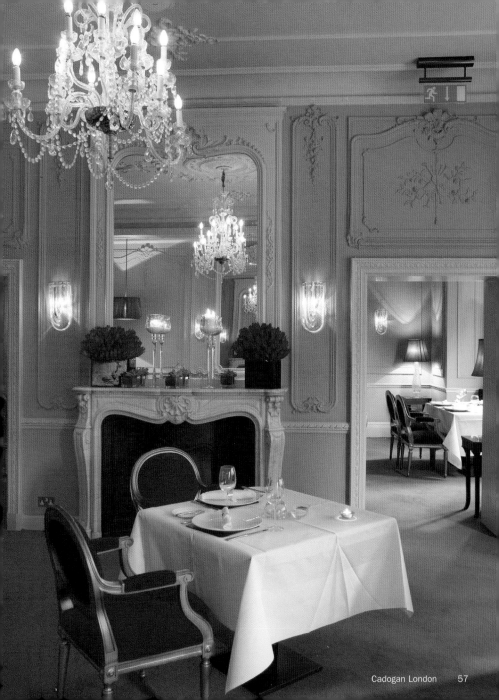

The Caesar

26–33 Queen's Gardens
Bayswater
London, W2 3BD
Phone: +44 20 7262 0022
Fax: +44 20 7402 5099
www.derbyhotels.com

Cool Restaurants nearby:
43 South Molton
Tom's Delicatessen

Cool Shops nearby:
10500 Hairdressers
Laundry Industry
Paul Smith Westbourne House

Price category: £
Rooms: 148
Facilities: XO Restaurant & Bar, garden
Services: Room service
Located: In Central London, in the residential area of Queen's Gardens, near Hyde Park
Tube: Bayswater, Queensway, Lancaster Gate
Map: No. 10
Style: Contemporary design
What's special: In pleasant surroundings and set in a typical Victorian building. A creative and elegant hotel to enjoy a lively, present-day atmosphere. Multiethnic and multicultural with friendly service.

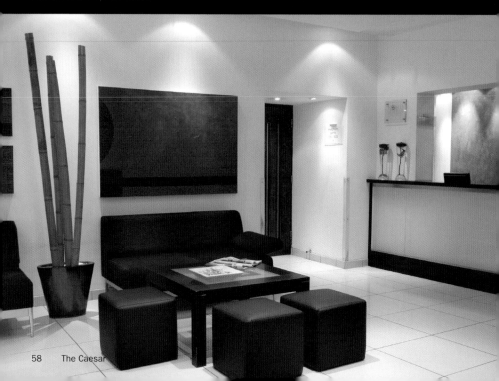

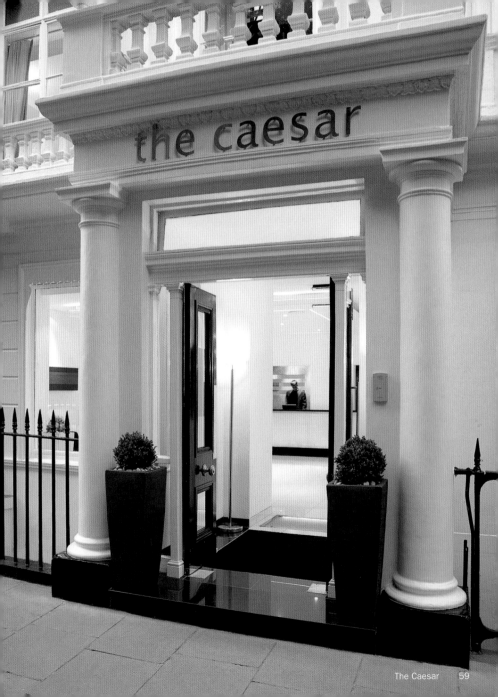

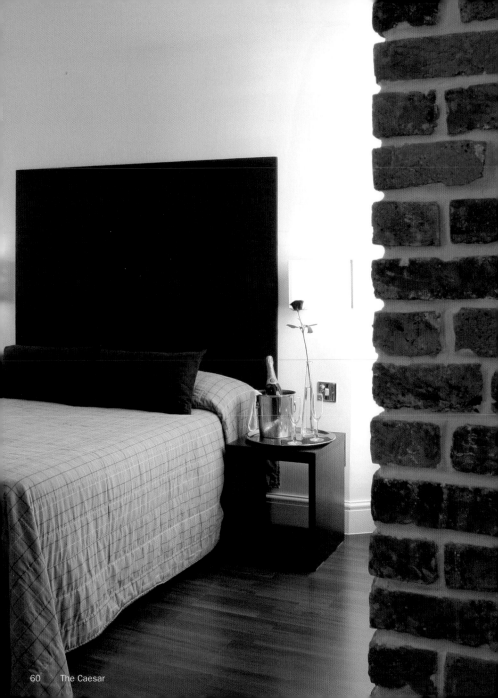

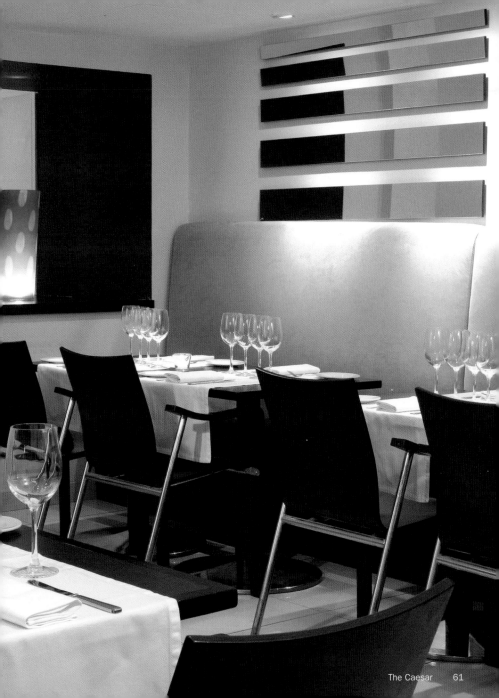

Charlotte Street

15–17 Charlotte Street
Soho
London, W1T 1RJ
Phone: +44 20 7806 2000
Fax: +44 20 7806 2002
www.firmdale.com

Cool Restaurants nearby:
Bam-Bou
Hakkasan
Salt Yard

Cool Shops nearby:
Donna Karan
Lush
Yauatcha

Price category: £££
Rooms: 52 rooms and suites
Facilities: Restaurant, bar, fully equipped multi-media screening room, gym
Services: 24-hour room service
Located: A minute's walk from Soho Square and the theater district
Tube: Goodge Street, Tottenham Court Road
Map: No. 11
Style: Cosy and romantic
What's special: The interiors, designed by Kit Kemp, reflect a fresh, modern English style. A "Bloomsbury set" theme has been used in many of the rooms and the drawing rooms are in the spirit of Bloomsbury painters Vanessa Bell and Duncan Grant.

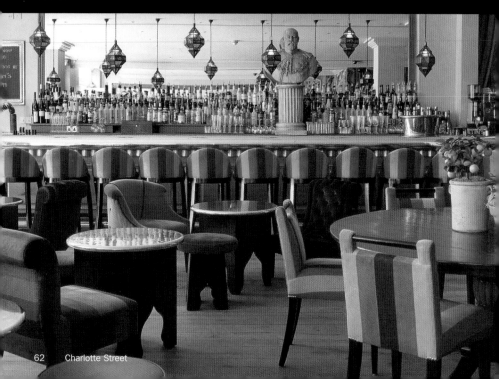

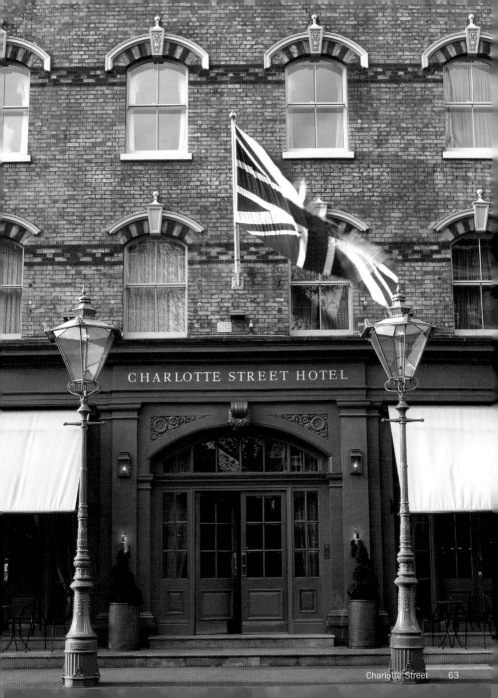

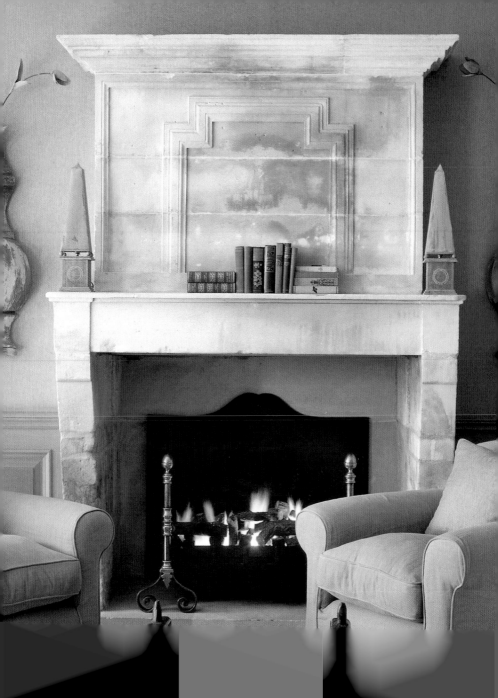

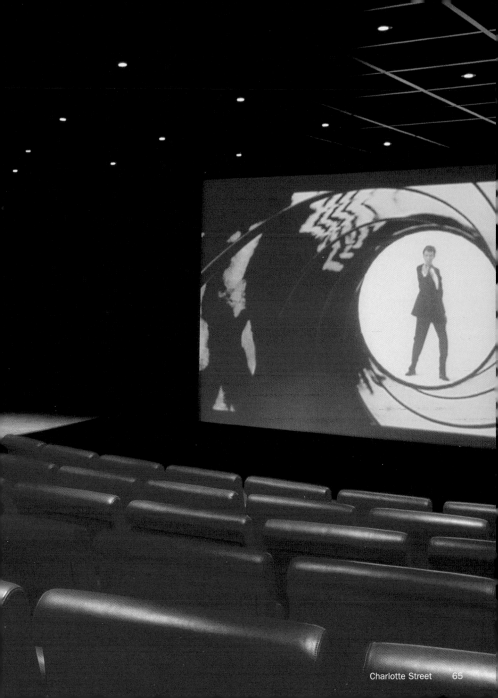

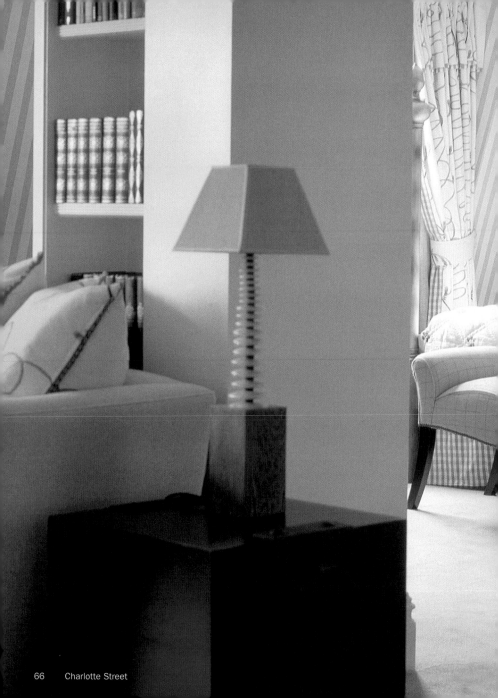

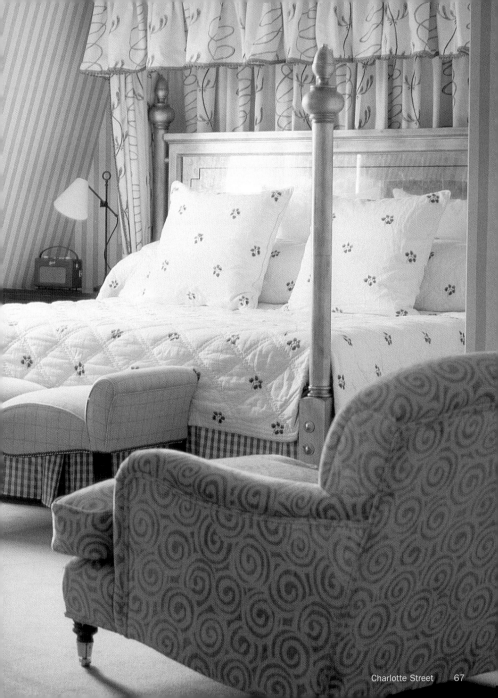

Claridge's

Brook Street
Mayfair
London, W1K 4HR
Phone: +44 20 7629 8860
Fax: +44 20 7499 2210
www.claridges.co.uk

Cool Restaurants nearby:
43 South Molton
Umu

Cool Shops nearby:
Miller Harris
Sen
Vivienne Westwood

Price category: ££££
Rooms: 203 rooms and suites
Facilities: Restaurants & bars, health club & spa
Services: In-room massage, personal trainer
Located: Within easy reach of Hyde Park, Park Lane, Bond Street and Oxford Street
Tube: Bond Street
Map: No. 12
Style: Art Deco and traditional
What's special: Noblesse oblige! This is the number one address for British and foreign aristocracy. A unique Art Deco jewel yet being impressively chic with its silver-white light and glass sculpture suspended from the ceiling in the foyer.

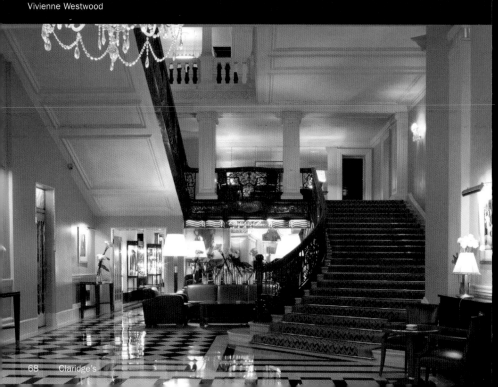

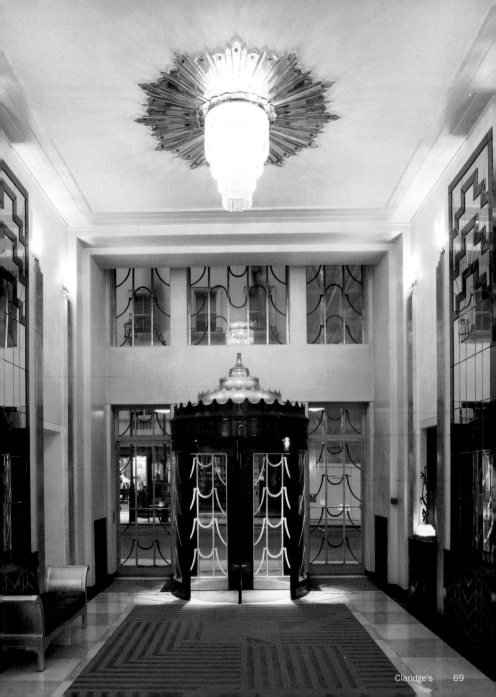

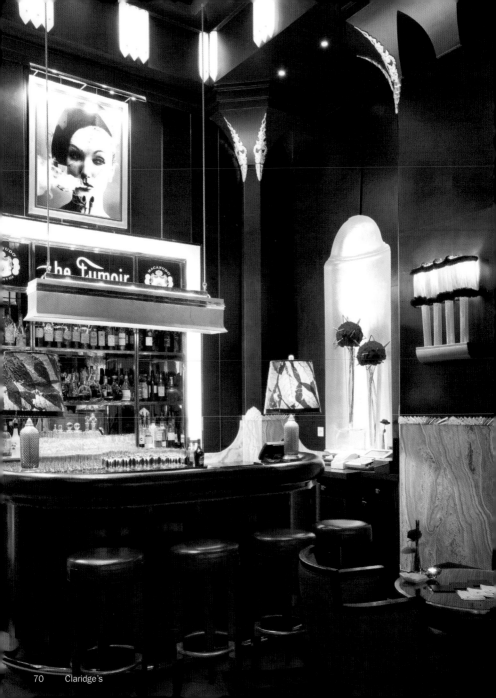

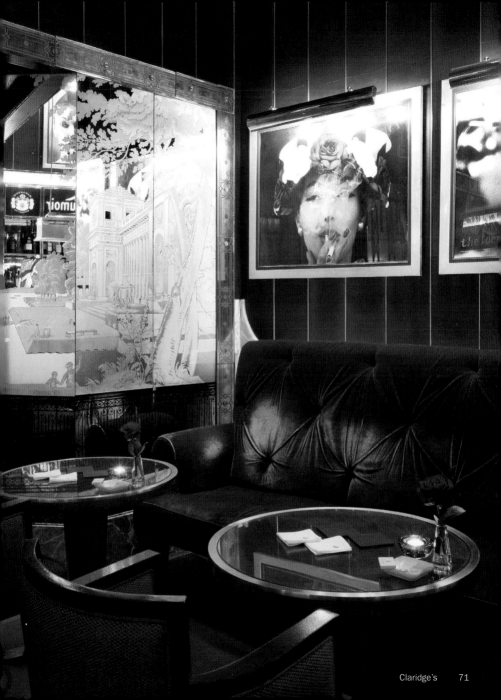

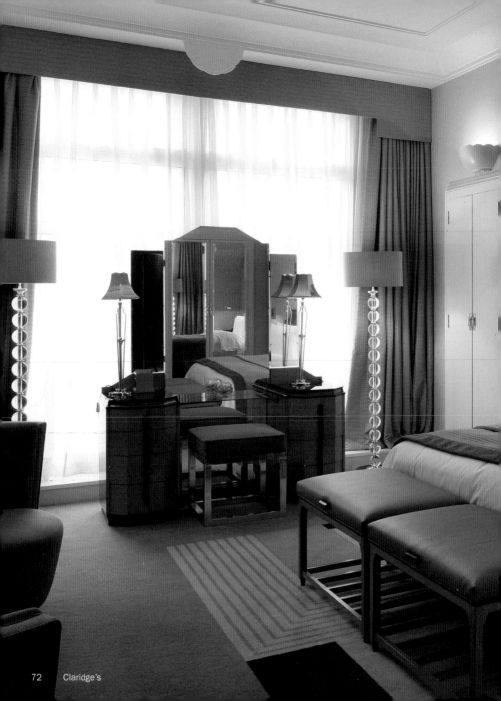

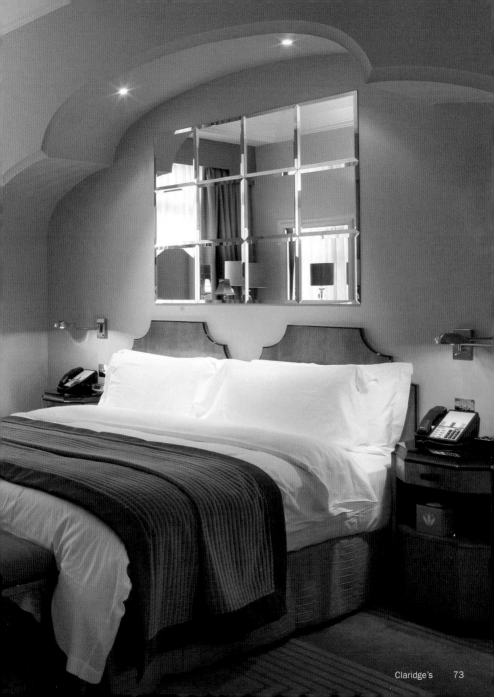

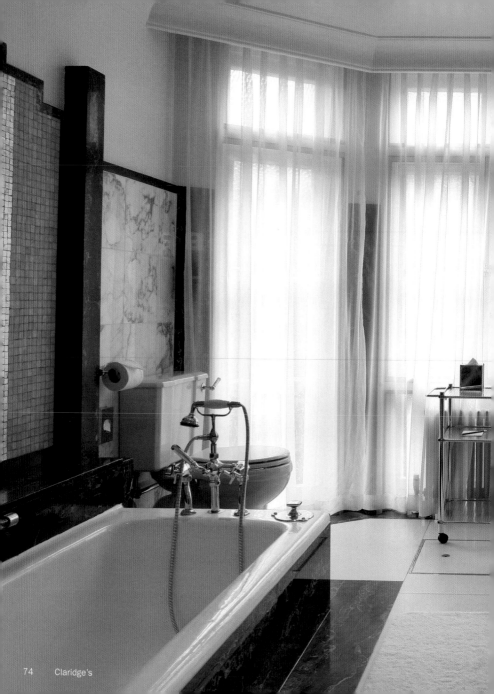

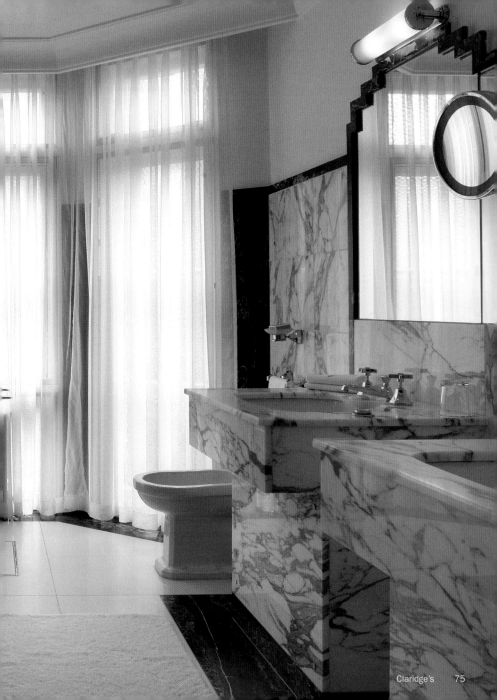

Courthouse Hotel Kempinski

19–21 Great Marlborough Street
Soho
London, W1F 7HL
Phone: +44 20 7297 5555
Fax: +44 20 7297 5566
www.courthouse-hotel.com

Cool Restaurants nearby:
Mo*vida
Sketch
Yauatcha

Cool Shops nearby:
Lush
Playlounge
Vivienne Westwood

Price category: £££
Rooms: 112 bedrooms and suites
Facilities: 3 restaurants, The Bar, Sanook Spa, swimming pool, gym, private screening room, roof terrace, event space to hold up to 200 guests
Services: Chauffeur and babysitting upon request
Located: Set in the heart of London's bustling Soho
Tube: Oxford Circus
Map: No. 13
Style: Contemporary design
What's special: Situated in what was once the largest magistrates court in London, the Courthouse Hotel has retained many original features including the old Courtroom Number One and prison cells now used as private drinking booths.

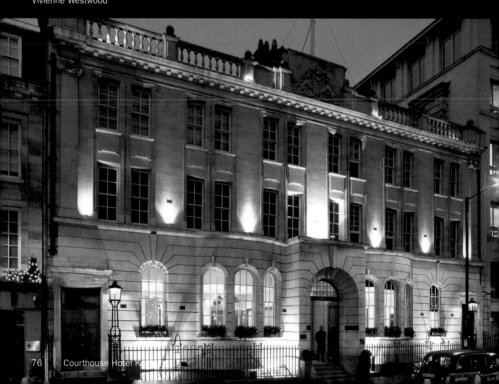

Courthouse Hotel Kempinski 77

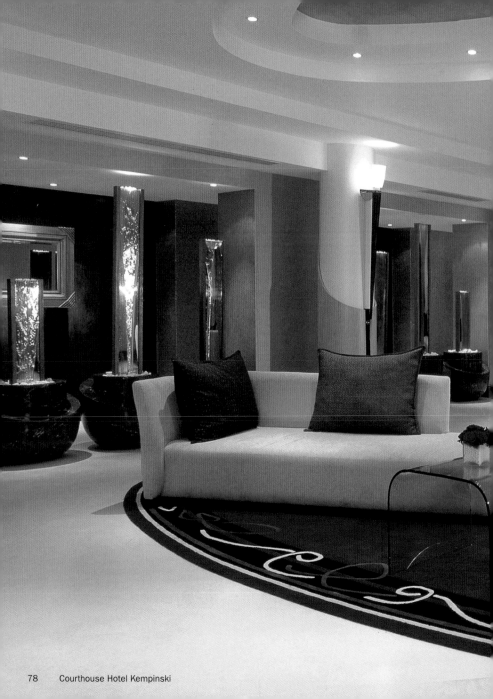

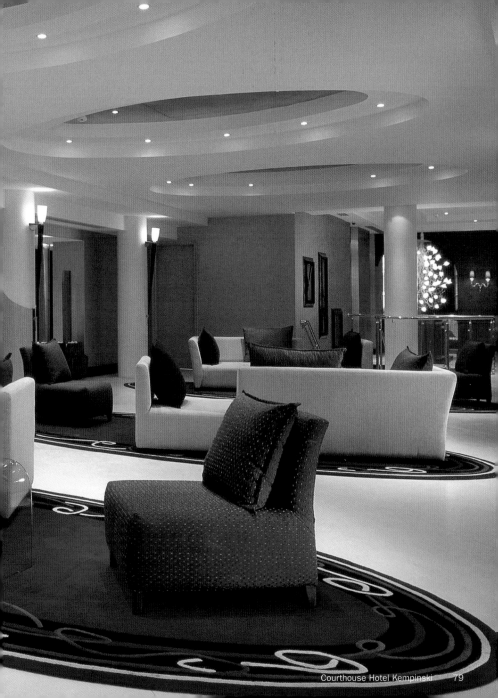

Durley House

115 Sloane Street
Knightsbridge
London, SW1X 9PJ
Phone: +44 20 7235 5537
Fax: +44 20 7259 6977
www.steinhotels.com/durley

Cool Restaurants nearby:
Boxwood Café
Pétrus
Fifth Floor

Cool Shops nearby:
Alberta Ferretti
Allegra Hicks
Dolce & Gabbana

Price category: ££££
Rooms: 11 suites
Facilities: Health club & spa
Services: Personal shopper, in-house dining, banqueting, tennis
Located: Just minutes away from Kings Road
Tube: Sloane Square, Knightsbridge
Map: No. 14
Style: Classic elegance
What's special: 18th century townhouses converted in an "all suite hotel" elegantly furnished with selected antiques. Suites fitted with spacious kitchens to prepare your own meal—ideal when traveling with children. Enjoy a picnic in the private gardens. Durley House is a Member of Stein Hotels and Resorts.

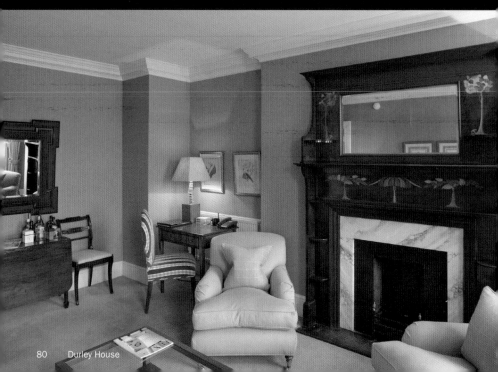

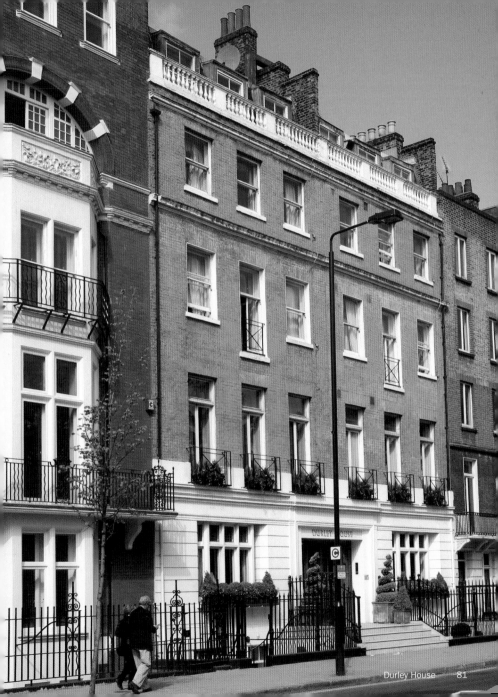

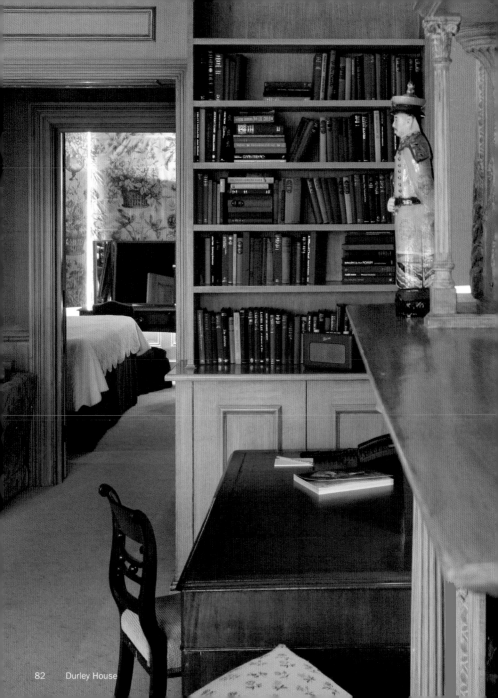

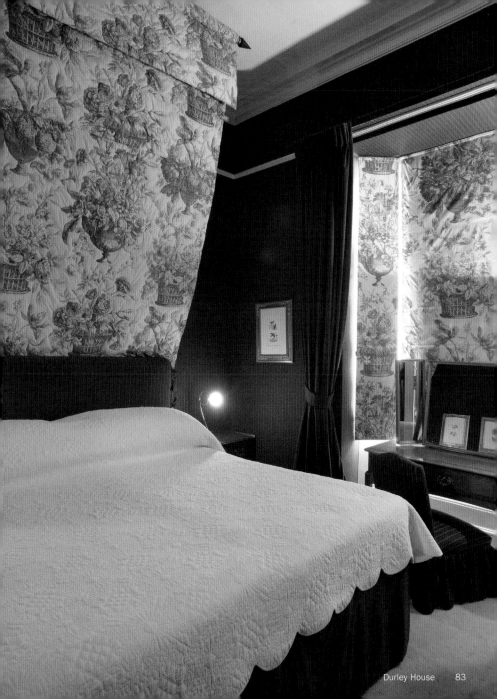

Four Seasons Hotel Canary Wharf

46 Westferry Circus
Canary Wharf
London, E14 8RS
Phone: +44 20 7510 1999
Fax: +44 20 7510 1998
www.fourseasons.com/canary-wharf

Cool Restaurants nearby:
Plateau

Cool Shops nearby:
Comfort Station
Junky Styling
Unto this last

Price category: ££££
Rooms: 142 rooms and suites
Facilities: Restaurant, bar, pool, spa
Services: In-room dining, family-oriented activities, tennis
Located: In London's newest financial center
Tube: Canary Wharf
Map: No. 15
Style: Urban chic
What's special: Set in an ultramodern tower, right in the middle of Canary Wharf, London's newest financial center makes it ideal for the business traveler. A 20-meter infinity-edge swimming pool overlooking the River Thames.

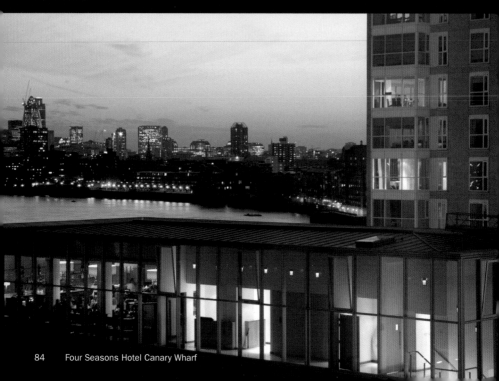

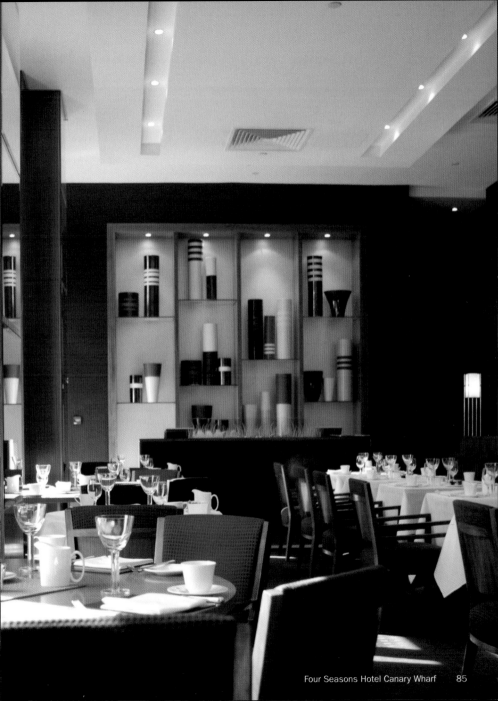

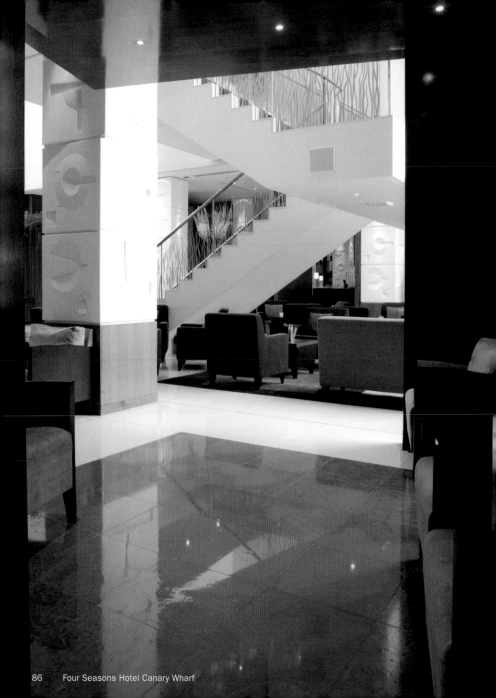

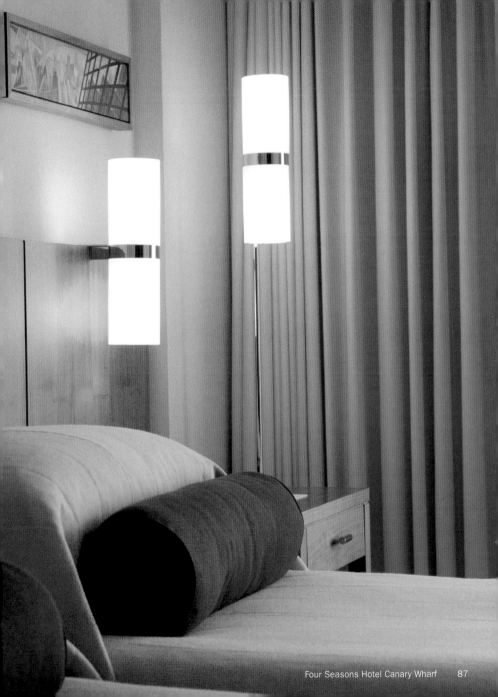

Hazlitt's

6 Frith Street
Soho
London, W1D 3JA
Phone: +44 20 7434 1771
Fax: +44 20 7439 1524
www.hazlittshotel.com

Cool Restaurants nearby:
Bam-Bou
Hakkasan
Yauatcha

Cool Shops nearby:
Lush
Playlounge
Yauatcha

Price category: £££
Rooms: 23
Services: Complimentary wireless internet access, mini-bar, fully air-conditioned.
Located: In the heart of Soho, just minutes away from Covent Garden
Tube: Tottenham Court Road, Leicester Square
Map: No. 16
Style: Rustic elegance
What's special: Located in Soho, in the heart of London's cosmopolitan Theatreland, with an intimate charm no large hotel can match. Filled with character and discreet service—very English indeed!

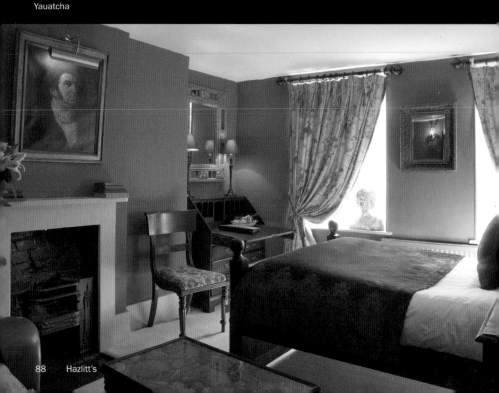

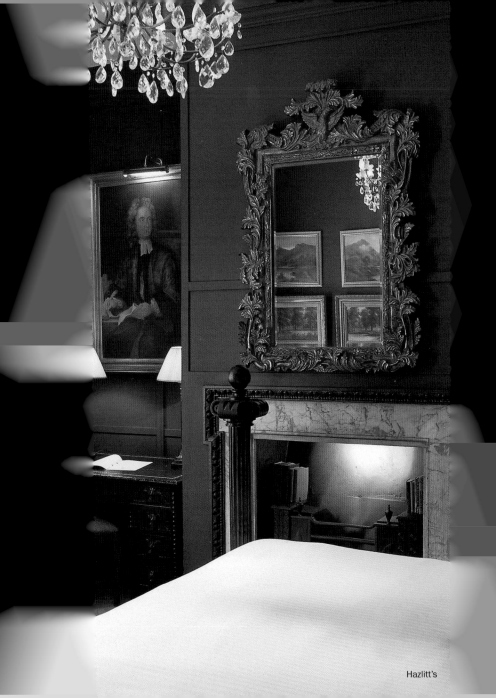

Hazlitt's

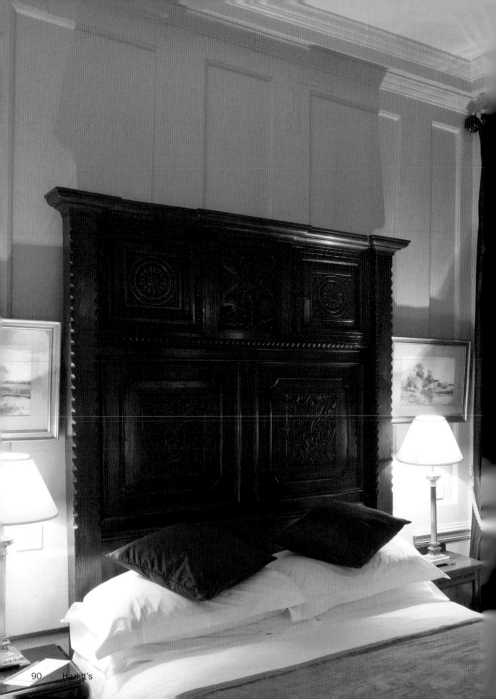

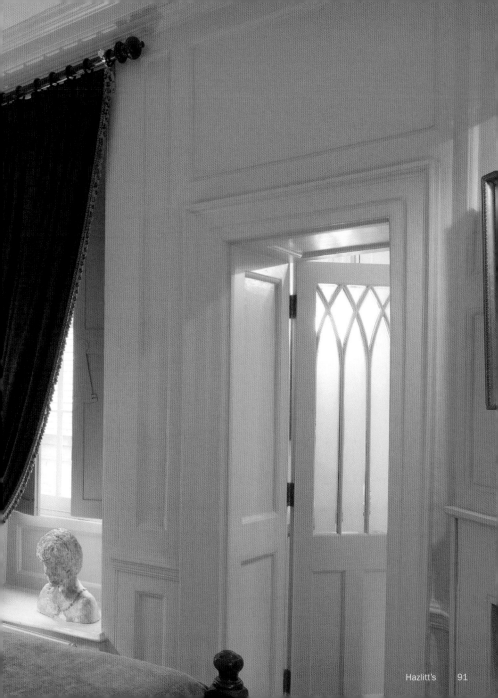

London, W4 1PR
Phone: +44 20 8742 1717
Fax: +44 20 8987 8762
www.highroadhouse.co.uk

Cool Restaurants nearby:
The Glasshouse
The River Café

Cool Shops nearby:
10500 Hairdressers
Laundry Industry
Paul Smith Westbourne House

Facilities: 2 restaurants, bars, private members' club with pool and football tables, board games, 61" plasma screen for private screening and parties
Services: Internet access, Cowshed products in all rooms
Located: On Chiswick High Road in a relaxed area of busy London
Tube: Turnham Green
Map: No. 17
Style: Nordic
What's special: Three-in-one hotel, brasserie and retail shop with a modern, fresh concept and design. The rooms are wood panelled and painted white in the style of a Scandinavian cottage.

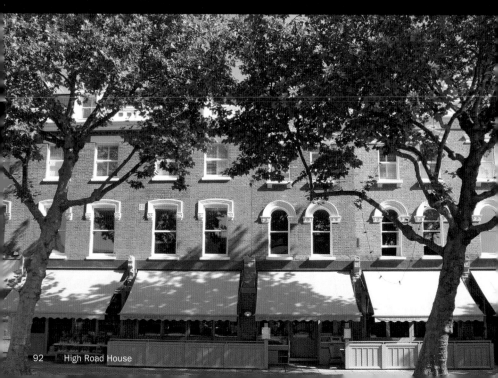

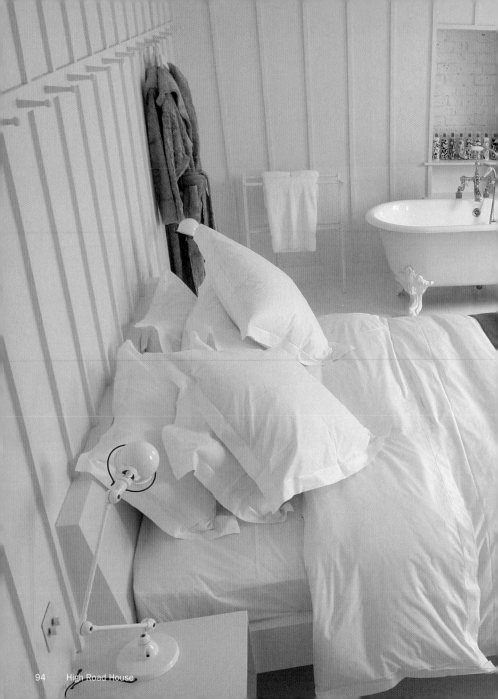

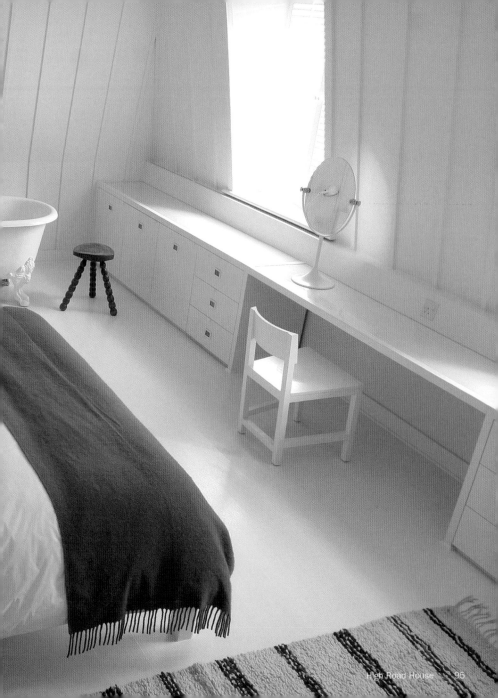

Kensington Rooms

131–137 Cromwell Road
Kensington
London, SW7 4DU
Phone: +44 20 7598 7979
Fax: +44 20 7598 7981
www.kensingtonrooms.co.uk

Cool Restaurants nearby:
Fifth Floor
The Admiral Codrington

Cool Shops nearby:
Diesel
Espacio
Poliform

Price category: £
Rooms: 88
Facilities: Bar, media suite, gym and pool at David Lloyd Fitness Center located directly opposite the hotel
Services: Corporate events, private parties, weddings
Located: Just west of the vibrant shops, restaurants and bars of Knightsbridge
Tube: Gloucester Road
Map: No. 18
Style: Contemporary design
What's special: Cutting-edge but comfortable, friendly but unfussy, offering the eclectic fusion of beautiful, original features, innovative designer furniture and ambient lighting right in the heart of Kensington.

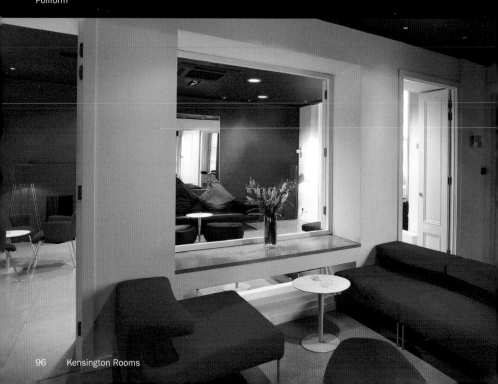

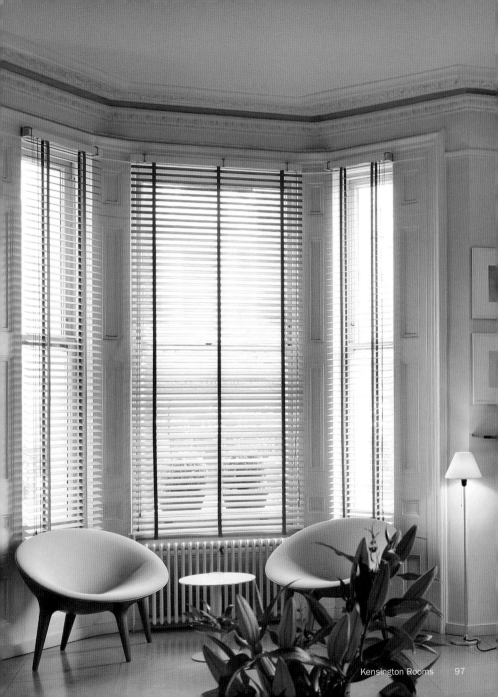

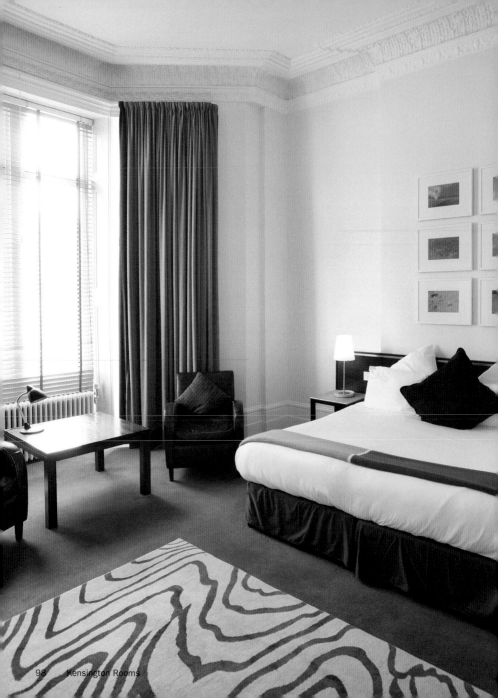

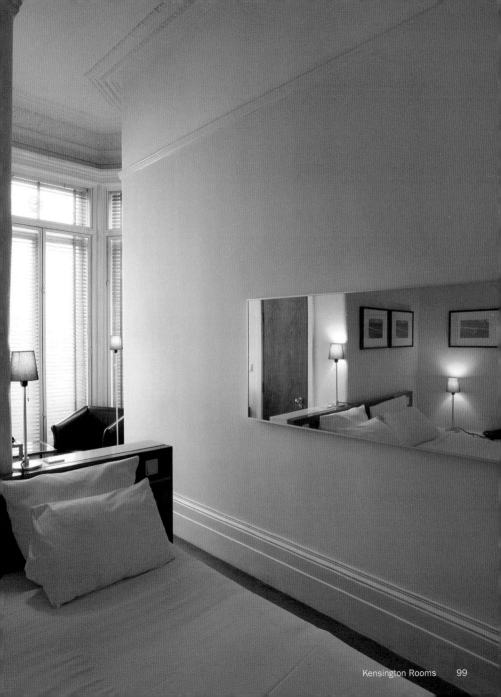

Knightsbridge Hotel

10 Beaufort Gardens
Knightsbridge
London, SW3 1PT
Phone: +44 20 7584 6300
Fax: +44 20 7584 6355
www.firmdale.com

Cool Restaurants nearby:
Boxwood Café
Fifth Floor
The Admiral Codrington

Cool Shops nearby:
Alberta Ferretti
Allegra Hicks
Dolce & Gabbana

Price category: ££
Rooms: 44 rooms and suites
Services: Concierge service, 24-hour room service
Located: Harrods, Harvey Nichols and the international designer stores of Sloane Street and Brompton Cross are a minutes walk away
Tube: Knightsbridge
Map: No. 19
Style: Modern country chic
What's special: An art filled luxury boutique hotel with African themes in the drawing room, soft pastels in the library both fitted with fireplaces creating a cosy, country house style atmosphere and yet modestly priced.

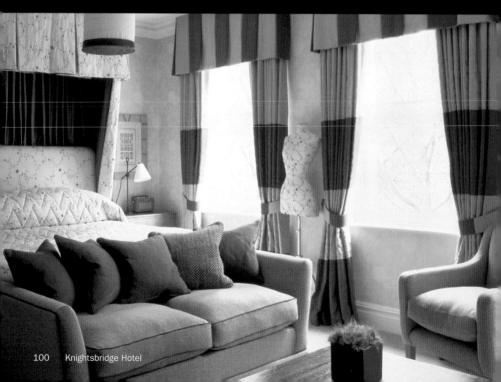

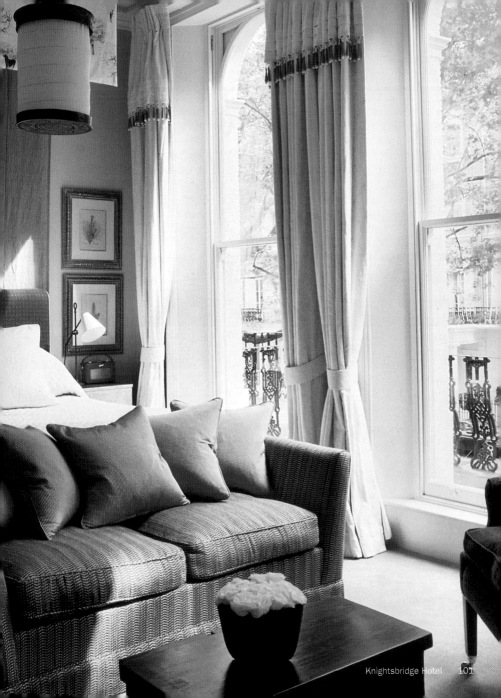

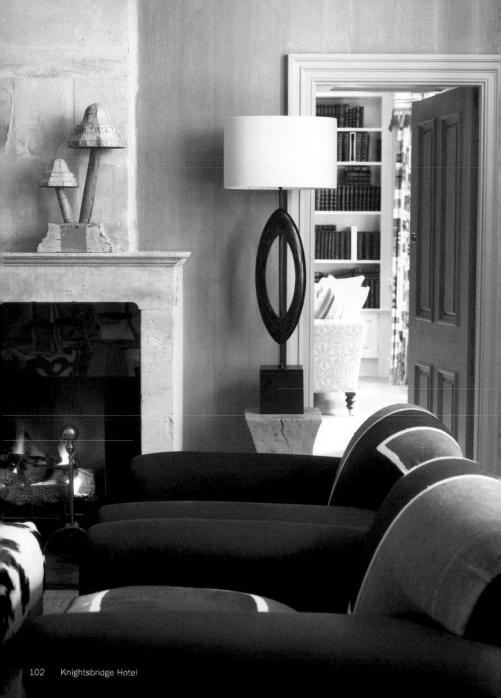

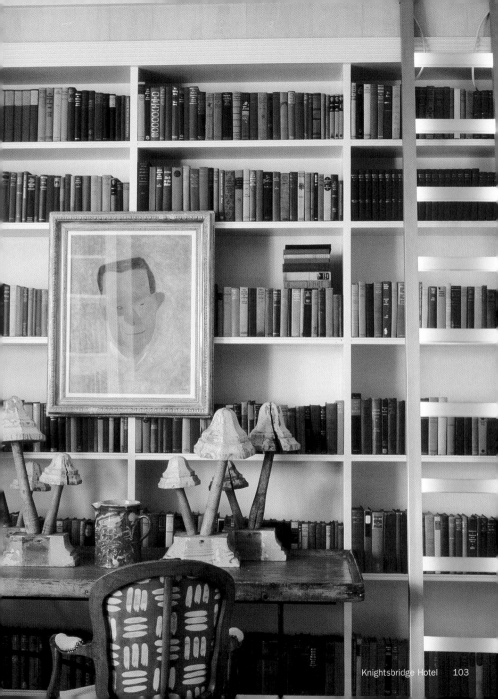

The Main House

6 Colville Road
Notting Hill
London, W11 2BP
Phone: +44 20 7221 9691
www.themainhouse.co.uk

Cool Restaurants nearby:
Tom's Delicatessen

Cool Shops nearby:
10500 Hairdressers
Laundry Industry
Paul Smith Westbourne House

Price category: £
Rooms: 4 rooms and 3 suites
Services: Free use of cell phones with private number and answer service, free wireless internet access, chauffeur service
Located: Located in Notting Hill, a minute from Portobello Road, antique markets, designer shops and art galleries
Tube: Notting Hill Gate
Map: No. 20
Style: Modern classic
What's special: The suites occupy an entire floor and are stylishly furnished with antiques from nearby Portobello Market reflecting an honest English style. A breakfast service is available at Tom Conran's deli on Westbourne Grove.

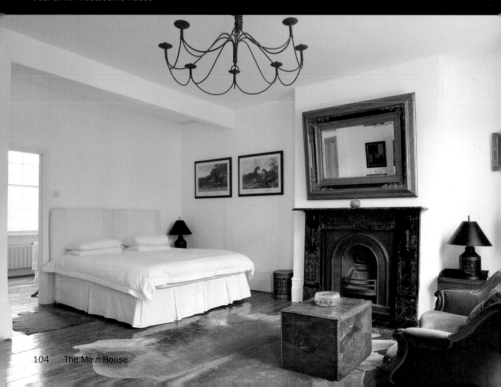

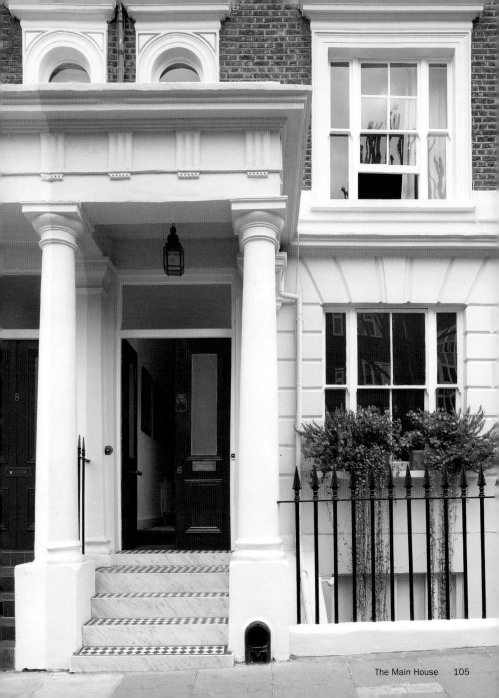

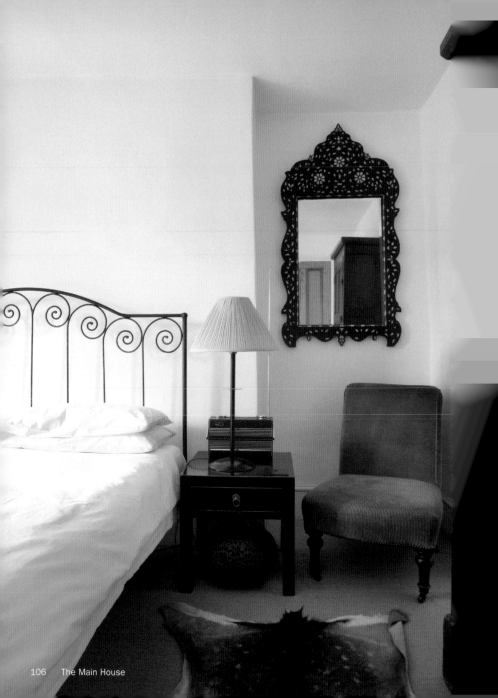

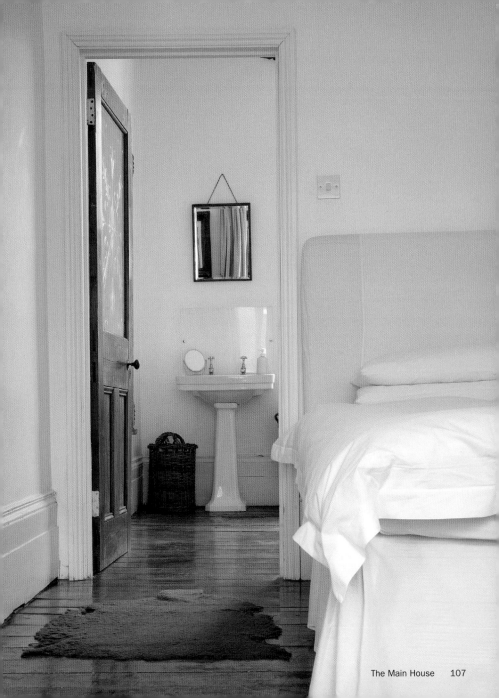

Malmaison London

Charterhouse Square
Clerkenwell
London, EC1M 6AH
Phone: +44 20 7012 3700
Fax: +44 20 7012 3702
www.malmaison.com

Price category: ££
Rooms: 95 rooms and 2 suites
Facilities: 2 boutique meeting rooms, brasserie, bar, gym
Services: Free internet access, same-day laundry
Located: Close to Farringdon or Barbican tube stations
Tube: Farringdon, Barbican
Map: No. 21
Style: Contemporary design
What's special: Spacious, stylishly designed rooms hosted in a red brick building overlooking a garden square in fashionable Clerkenwell. The whole package comes to an affordable price.

Cool Restaurants nearby:
Fifteen
Moro

Cool Shops nearby:
Magma
Mathmos

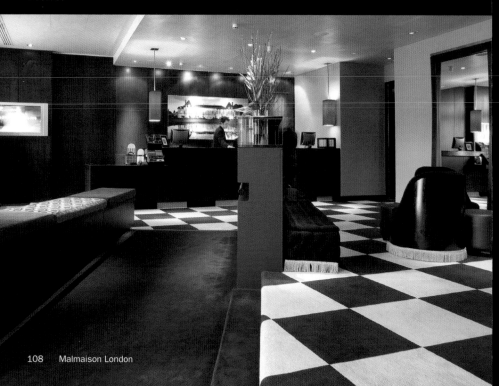

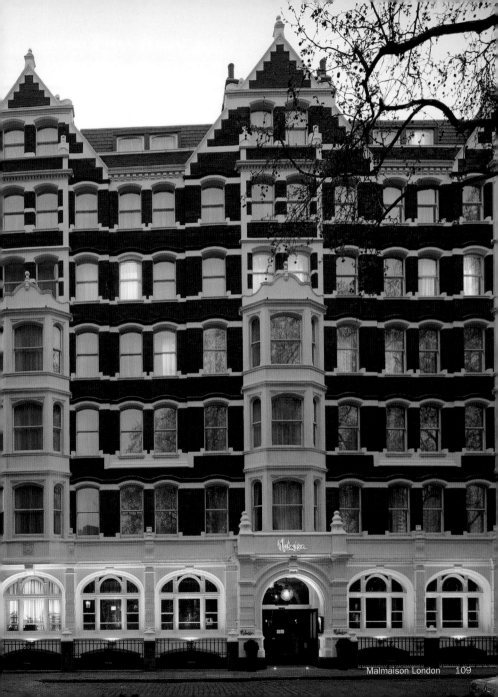

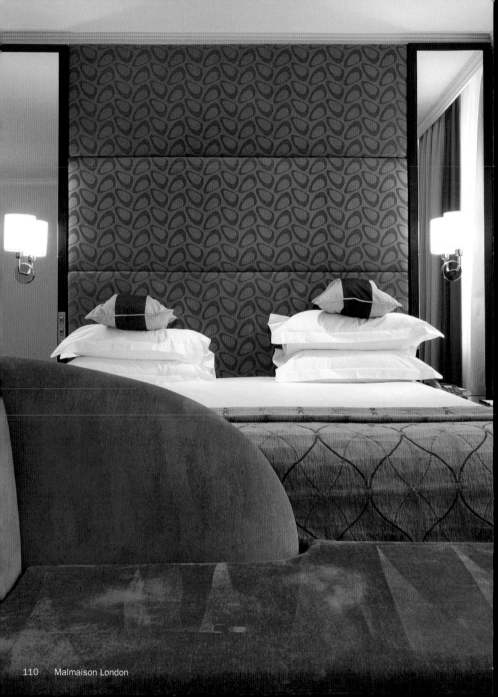

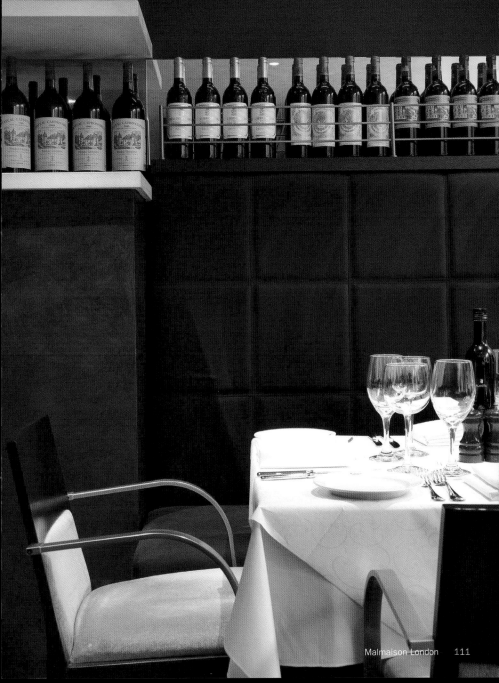

The May Fair

Stratton Street
Mayfair
London, W1J 8LT
Phone: +44 20 7629 7777
Fax: +44 20 7629 1459
www.radissonedwardian.com/
mayfair

Cool Restaurants nearby:
Automat
Umu

Cool Shops nearby:
Miller Harris
Stella McCartney

Price category: £££
Rooms: 406 rooms, 10 signature suites and 13 studio suites
Facilities: Restaurant & bar, casino, health spa, private theater
Services: Complimentary wireless internet access
Located: In the heart of Mayfair, the hotel is close to Bond Street and key financial and business districts
Tube: Green Park
Map: No. 22
Style: Contemporary design
What's special: It has undergone a £75 million refurbishment and has been furnished with creations from some of the world's top design houses. The luxury May Fair Spa—a sanctuary of zen-calm providing treatments is a key feature.

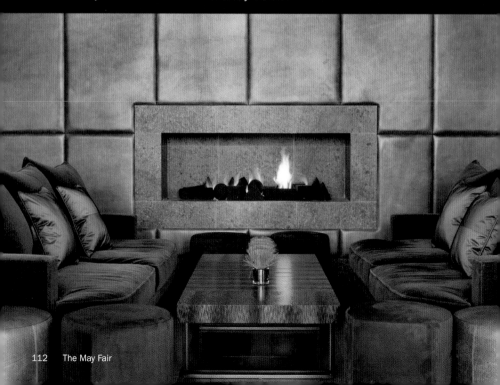

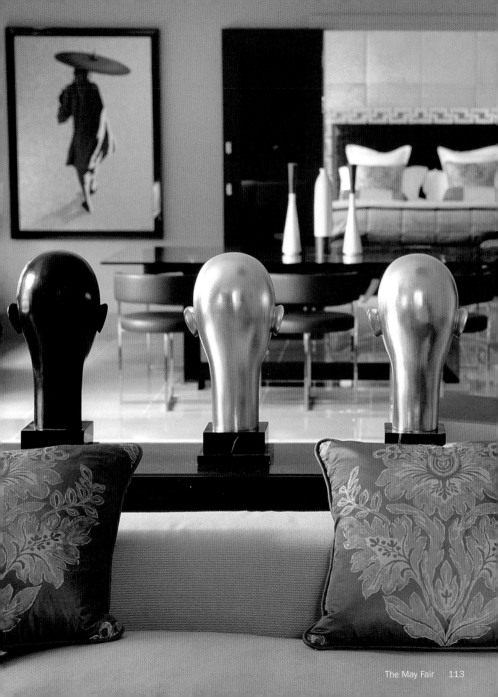

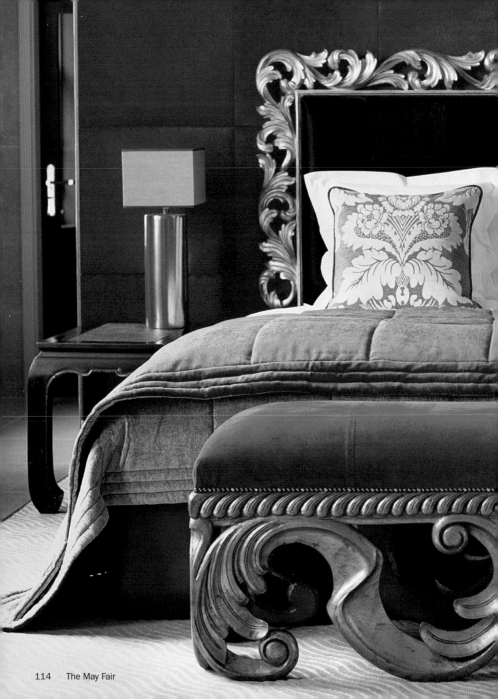

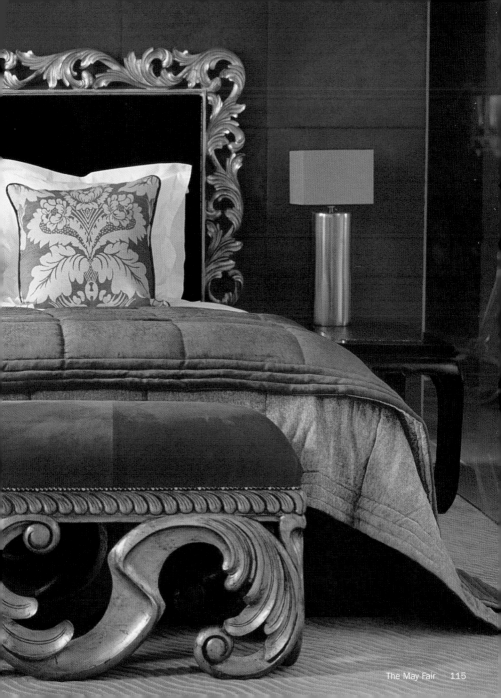

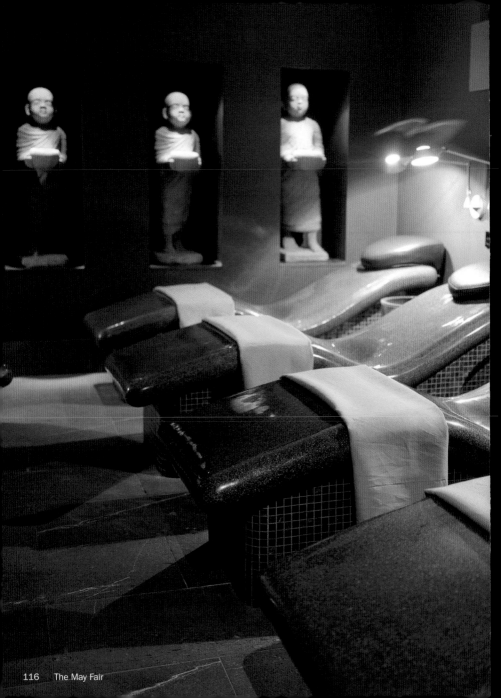

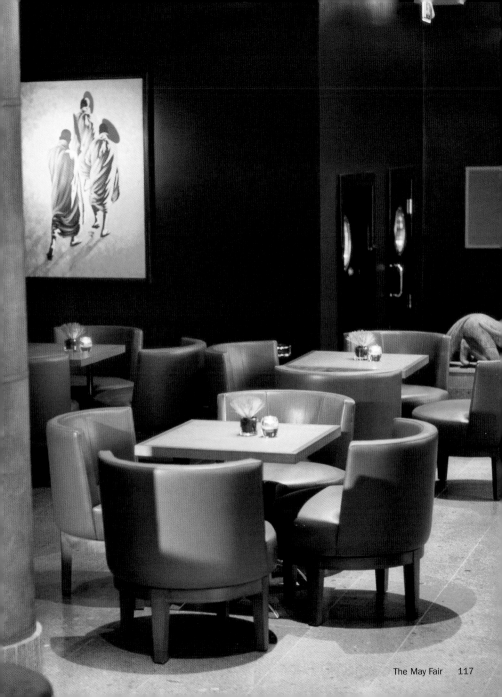

Mayfair
London, W1K 1LB
Phone: +44 20 7447 1000
Fax: +44 20 7447 1100
www.metropolitan.como.bz

Cool Restaurants nearby:
Boxwood Café
Fifth Floor

Cool Shops nearby:
Alberta Ferretti
Miller Harris
Stella McCartney

Rooms: 118 guest rooms, 31 suites and a Penthouse
Facilities: Japanese Peruvian Michelin-starred Nobu restaurant, members-only Met bar, COMO Shambhala Urban Escape, five event spaces for up to 80 guests
Services: Complimentary wireless internet access in all guest rooms and public areas
Located: In Mayfair, overlooking Hyde Park
Tube: Hyde Park Corner
Map: No. 23
Style: Contemporary design
What's special: London's leading stylish hotel offering the perfect mix of urban energy and cool escapism with one of hottest bars and award winning restaurants all under one roof.

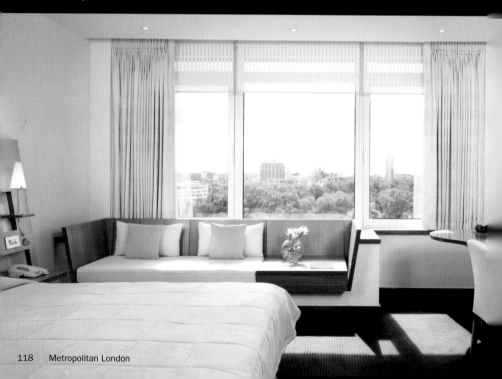

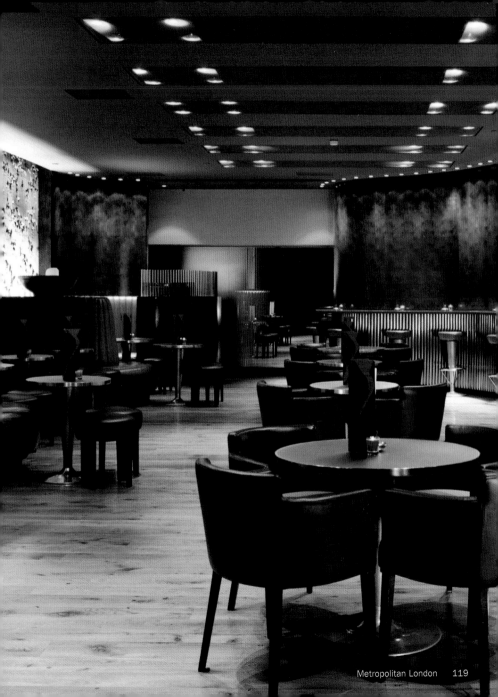

One Aldwych

1 Aldwych
Covent Garden
London, WC2B 4RH
Phone: +44 20 7300 1000
Fax: +44 20 7300 1001
www.onealdwych.com

Cool Restaurants nearby:
Axis
Criterion Grill
Hakkasan

Cool Shops nearby:
Lush
Magma
Yauatcha

Price category: ££££
Rooms: 105 rooms and suites
Facilities: Restaurants Axis & Indigo, The Lobby Bar,
The Cinnamon Bar, screening room, health club & pool
Services: 24-hour room service
Located: In the heart of London in Covent Garden,
between the City and the West End
Tube: Embankment, Covent Garden
Map: No. 24
Style: Contemporary design
What's special: A contemporary luxury hotel repre-
senting sleek and comfortable interiors in a converted
triangular commercial building located in vibrant Covent
Garden. In the basement is a stunning swimming pool
with underwater music.

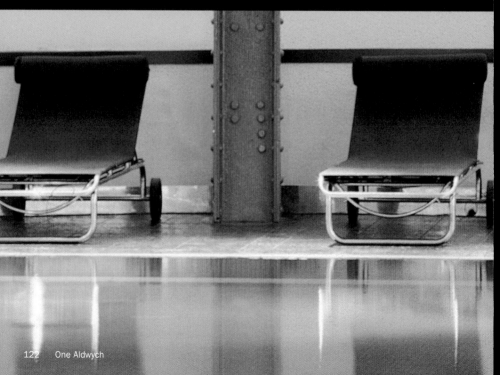

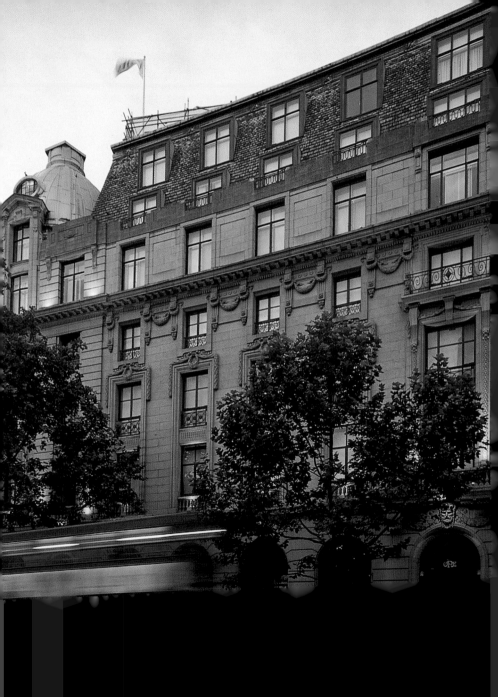

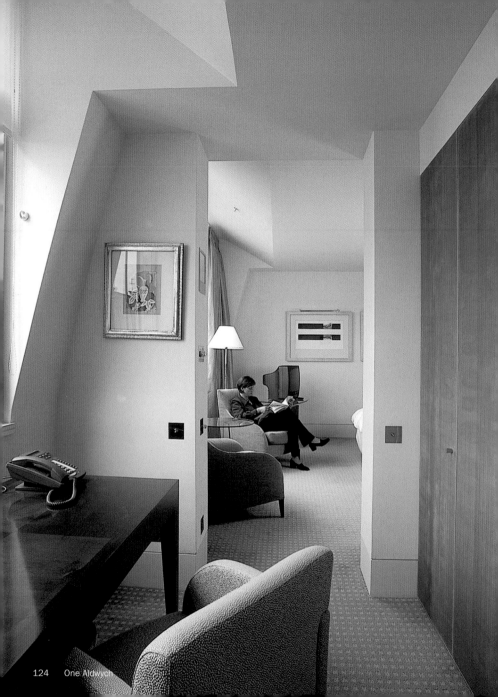

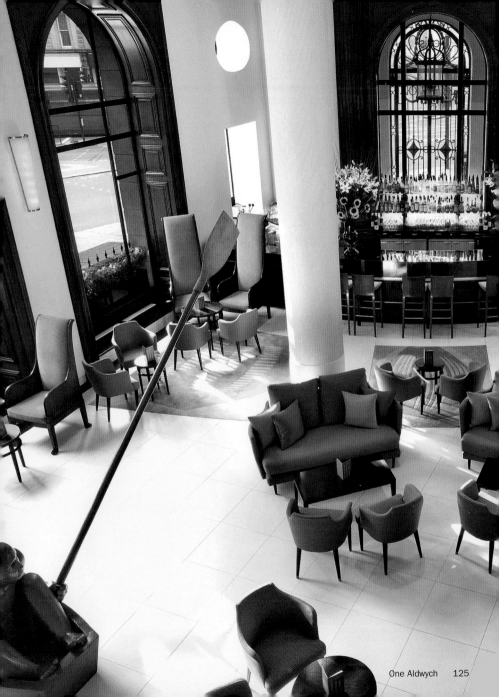

Park Plaza Sherlock Holmes

108 Baker Street
Marylebone
London, W1U 6LJ
Phone: +44 20 7034 4830
Fax: +44 20 7034 4822
www.sherlockholmeshotel.com

Cool Restaurants nearby:
43 South Molton
Nicole's
Umu

Cool Shops nearby:
Cox & Power
Donna Karan
Sen

Price category: ££
Rooms: 116 rooms, 3 loft suites
Facilities: Sherlock's Bar & Grill, holistic therapy room, gym, meeting rooms
Located: Walking distance to Madame Tussauds, Regent's Park, Hyde Park and Oxford Street
Tube: Baker Street
Map: No. 25
Style: Modern classic
What's special: It does not need a great detective to discover that this boutique style hotel is located at a first class location. The combination of heritage and modern style with soft furnishings creates a warm comfortable atmosphere.

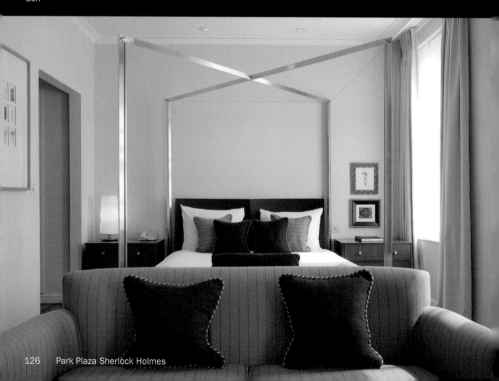

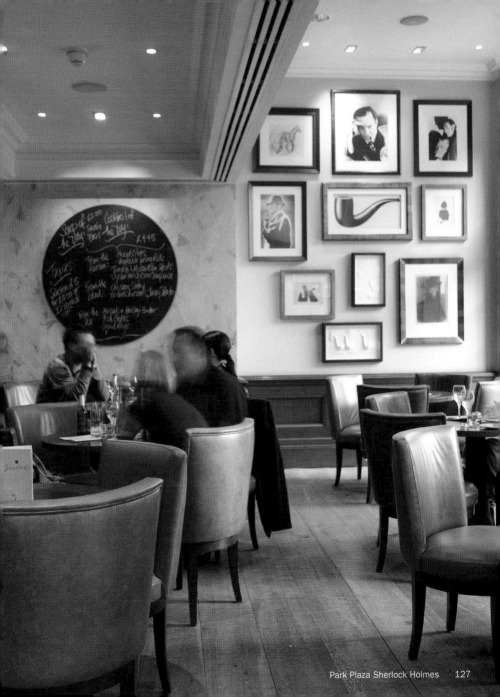

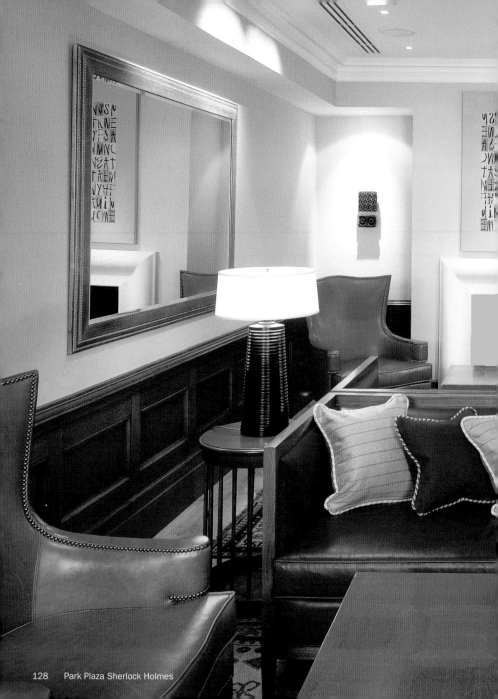

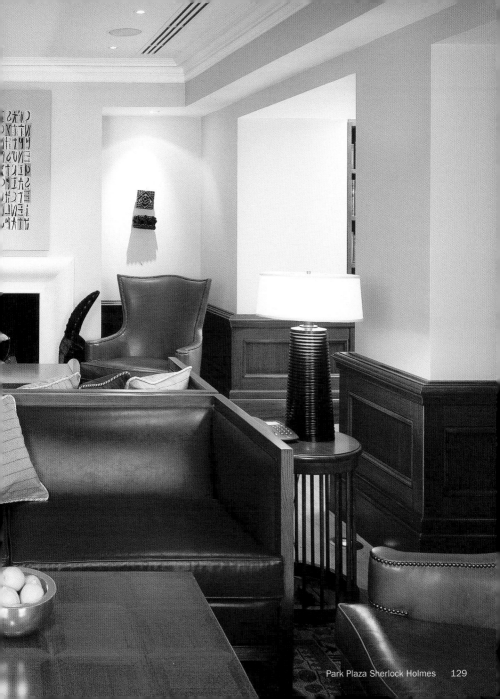

The Portobello Hotel

22 Stanley Gardens
Notting Hill
London, W11 2NG
Phone: +44 20 7727 2777
Fax: +44 20 7792 9641
www.portobellohotel.com

Cool Restaurants nearby:
Tom's Delicatessen

Cool Shops nearby:
10500 Hairdressers
Laundry Industry
Paul Smith Westbourne House

Price category: ££
Rooms: 23 rooms including 13 special rooms
Facilities: Restaurants & bar, health club facilities
4 minutes walk
Services: Free internet access, cell phone hire
Tube: Notting Hill Gate, Holland Park
Map: No. 26
Style: Neoclassical
What's special: On a quiet street in Notting Hill, just two blocks from the famous Portobello Market, stands this converted neoclassical mansion. It hardly looks like a hotel, yet it enjoys a worldwide reputation as one of the most exclusive hideaway hotels in London.

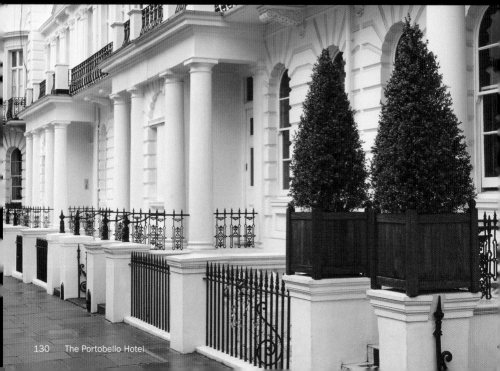

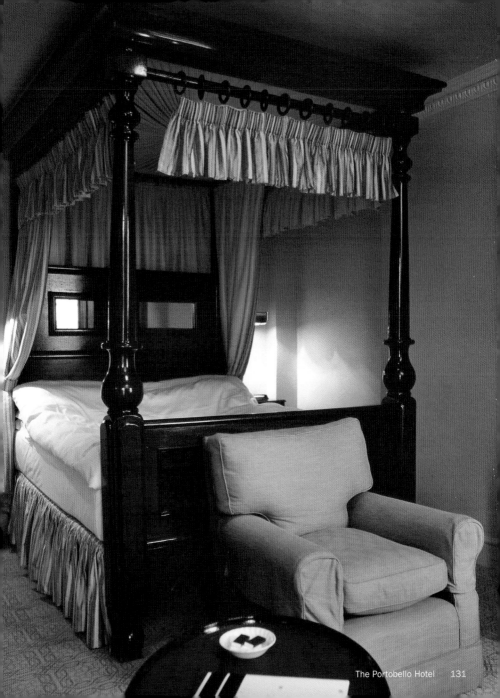

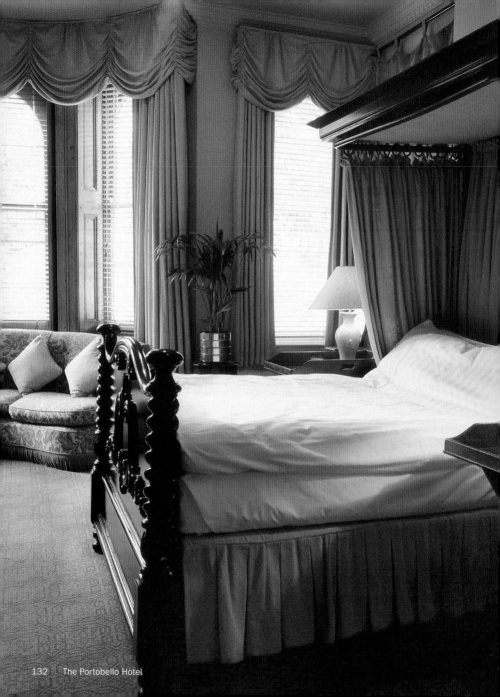

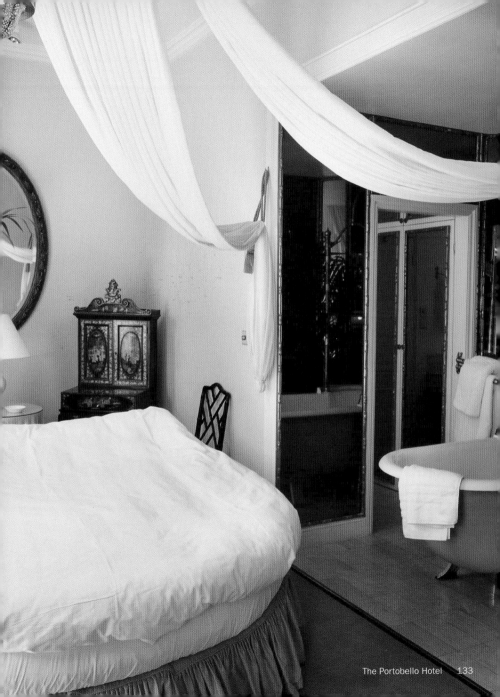

The Rockwell

181 Cromwell Road
Kensington
London, SW5 0SF
Phone: +44 20 7244 2000
Fax: +44 20 7244 2001
www.therockwellhotel.com

Cool Restaurants nearby:
Fifth Floor
The Admiral Codrington

Cool Shops nearby:
Diesel
Espacio
Poliform

Price category: ££
Rooms: 36 rooms and 4 suites
Facilities: Restaurant & bar, garden
Services: 24-hour room service
Located: In walking distance to Science Museum,
National History Museum and Victoria & Albert Museum
Tube: Earl's Court
Map: No. 27
Style: Contemporary design
What's special: An independent hotel with an emphasis
on understated contemporary style and English tradition.
In addition to the well-appointed bedroom, some of
which feature their own private patios, the hotel offers
the use of a south facing landscaped garden restaurant.

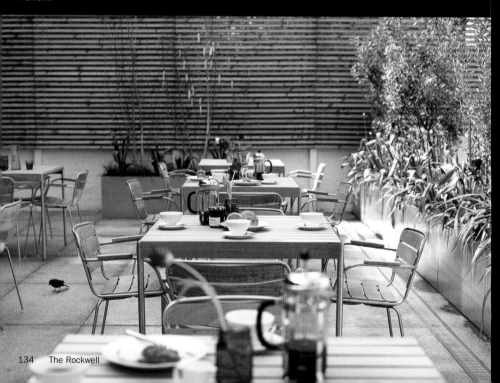

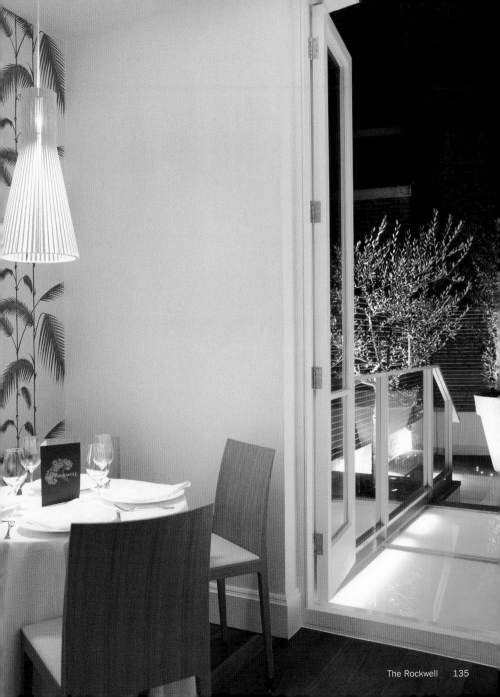

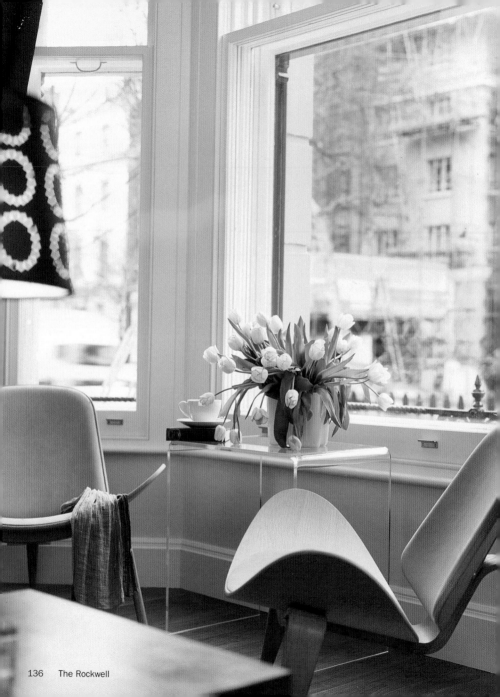

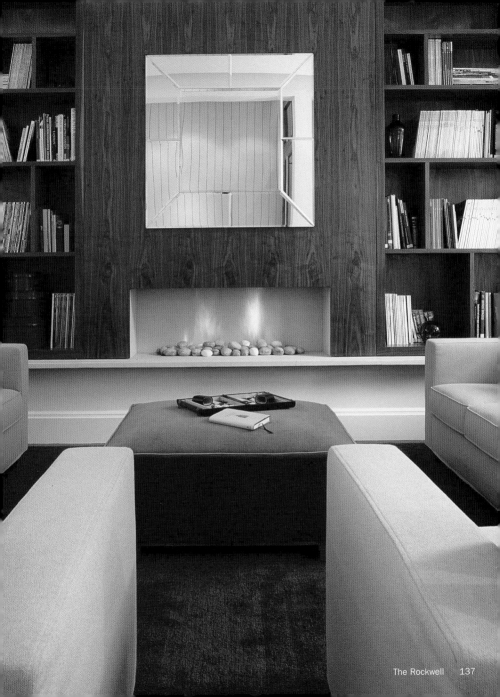

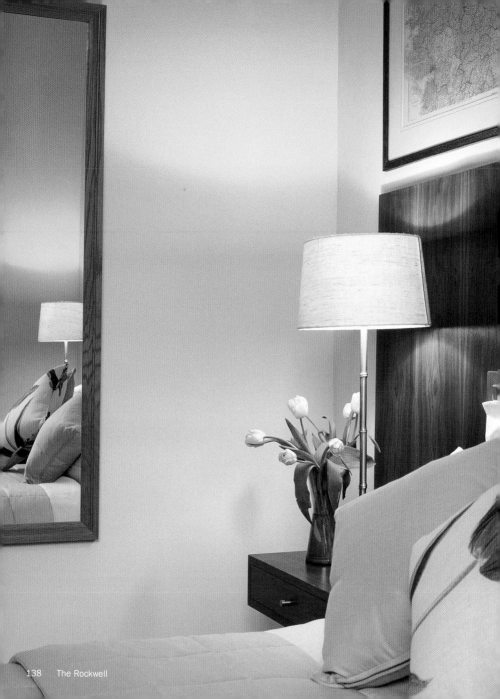

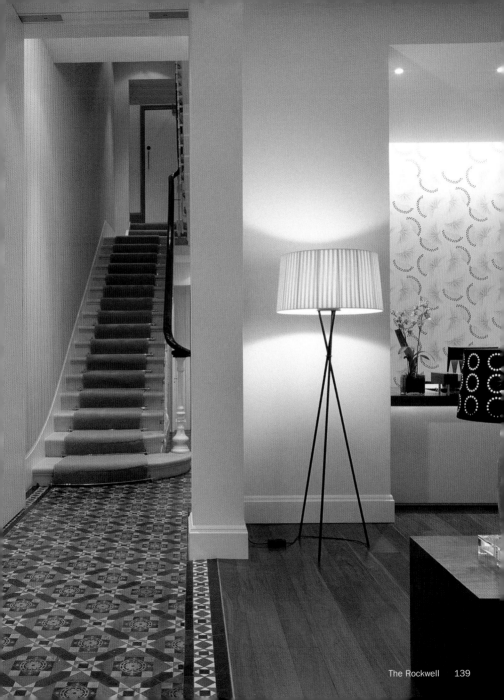

The Rookery

12 Peter's Lane
Clerkenwell
London, EC1M 6DS
Phone: +44 20 7336 0931
Fax: +44 20 7336 0932
www.rookeryhotel.com

Cool Restaurants nearby:
Fifteen
Moro

Cool Shops nearby:
Magma
Mathmos

Price category: £££
Rooms: 33 rooms
Facilities: 2 meeting rooms, courtyard garden, conservatory with honesty bar
Located: In the fashionable area of Clerkenwell, between the West End and London's central business district
Tube: Farringdon
Map: No. 28
Style: Rustic elegance
What's special: Inside, it is all period charm. Polished wood paneling, stone flagged floors, open fires and genuine antique furniture give the place a warm, homely atmosphere—more private club than hotel.

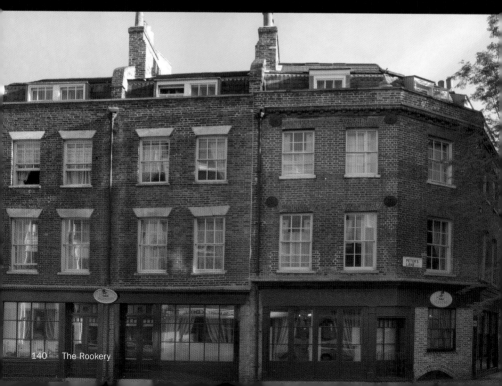

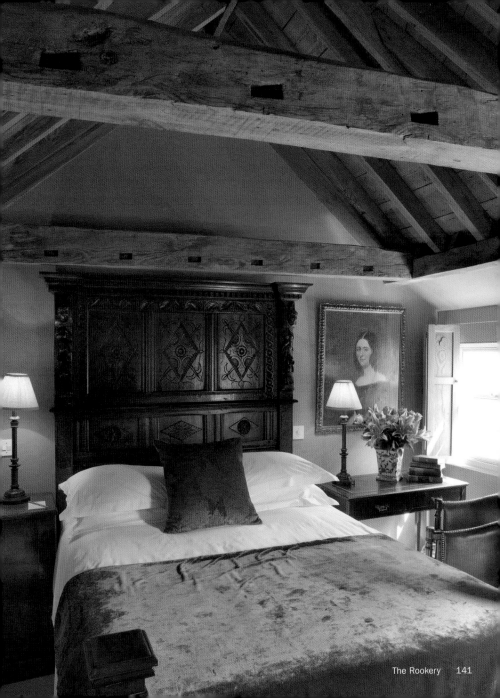

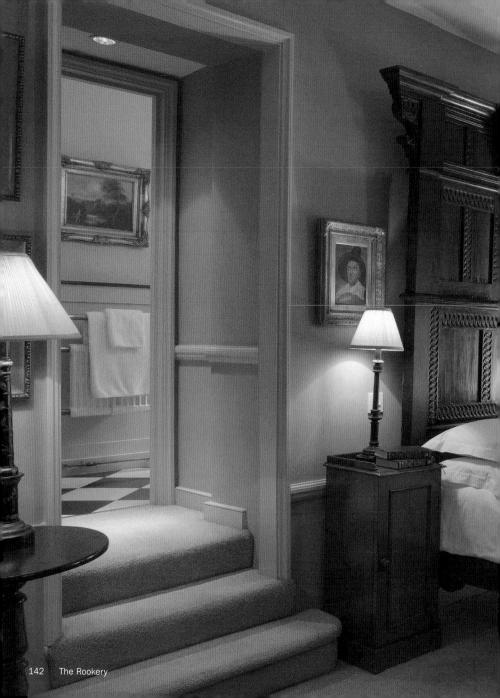

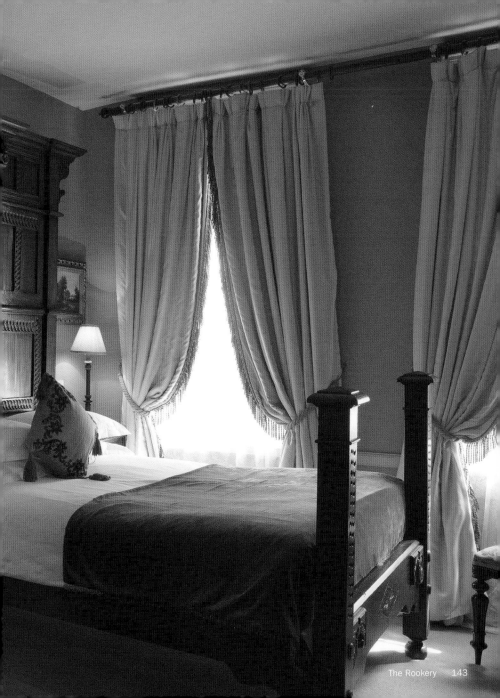

Threadneedles

5 Threadneedle Street
City of London
London, EC2R 8AY
Phone: +44 20 7657 8080
Fax: +44 20 7657 8100
www.theetoncollection.com

Cool Restaurants nearby:
Fifteen
Fish!

Cool Shops nearby:
The Scooter Emporium
Taylor Taylor

Price category: £££
Rooms: 70 rooms and suites
Facilities: Restaurant & bar
Services: 24-hour room service, personal business cards
Located: In the heart of London's financial district, the City.
Tube: Bank
Map: No. 29
Style: Contemporary design
What's special: A former bank building converted into a luxury boutique hotel. Impressive Victorian marble columns and a hand-painted glass cupola in the center echo the buildings' colorful past with a contemporary and rich interior.

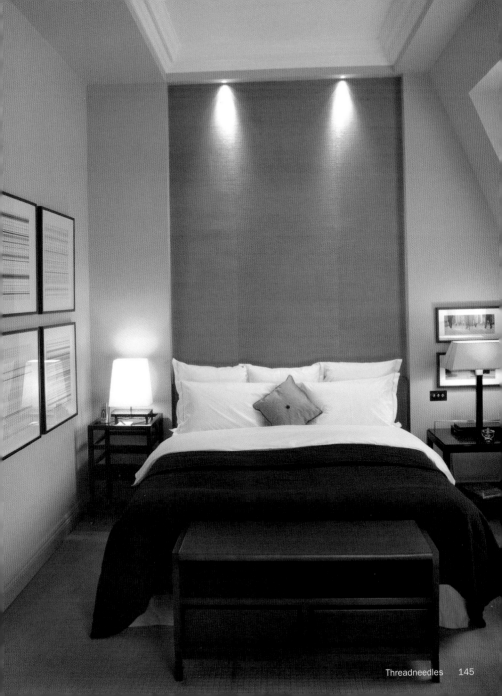

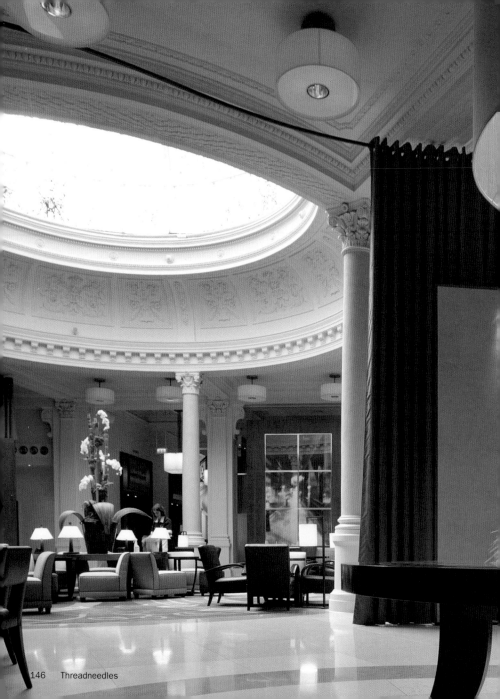

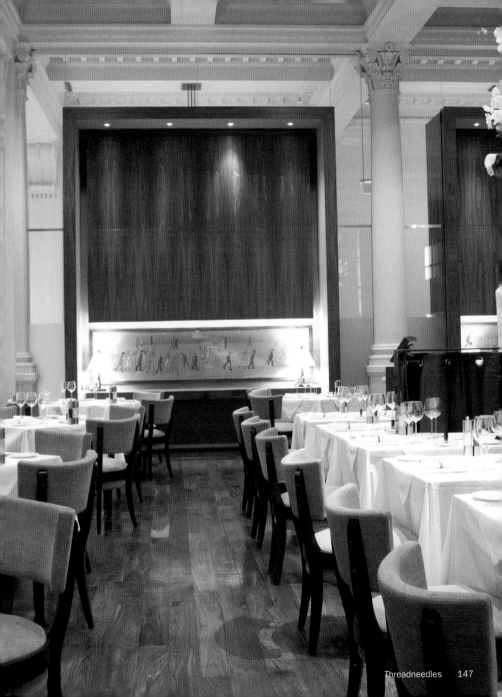

The Zetter

St John's Square
86–88 Clerkenwell Road
Clerkenwell
London, EC1M 5RJ
Phone: +44 20 7324 4444
Fax: +44 20 7324 4445
www.thezetter.com

Cool Restaurants nearby:
The Zetter Restaurant
Fifteen
Moro

Cool Shops nearby:
Magma
Mathmos

Price category: ££
Rooms: 59
Facilities: Restaurant, bar
Services: Parties and meetings
Located: A 10-minute taxi ride away from the West End
Tube: Farringdon
Map: No. 30
Style: Contemporary design
What's special: Cutting edge design brought to a converted 19th century Clerkenwell warehouse using young designers and artists to create a contemporary impression with wallpaper panels, artwork, ceramics and furniture. Rooftop studios are overlooking the City.

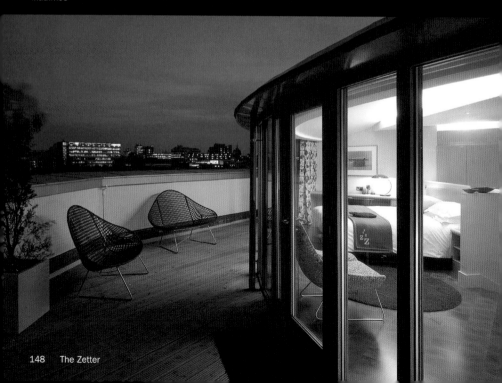

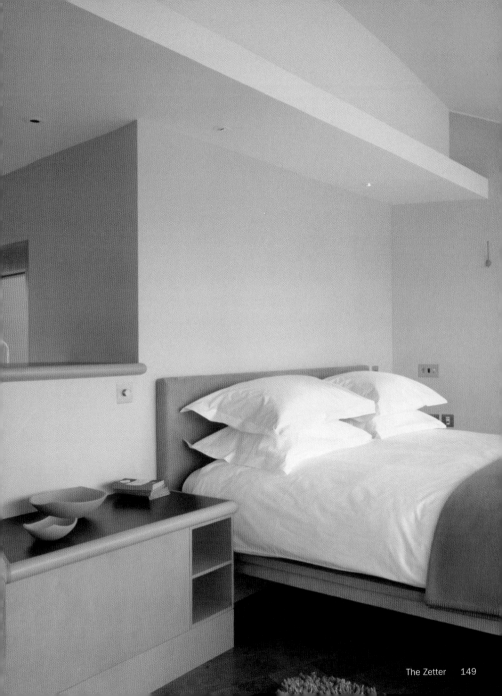

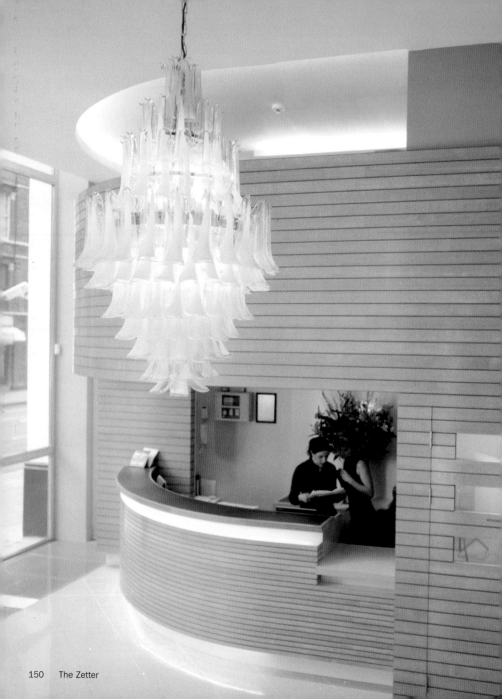

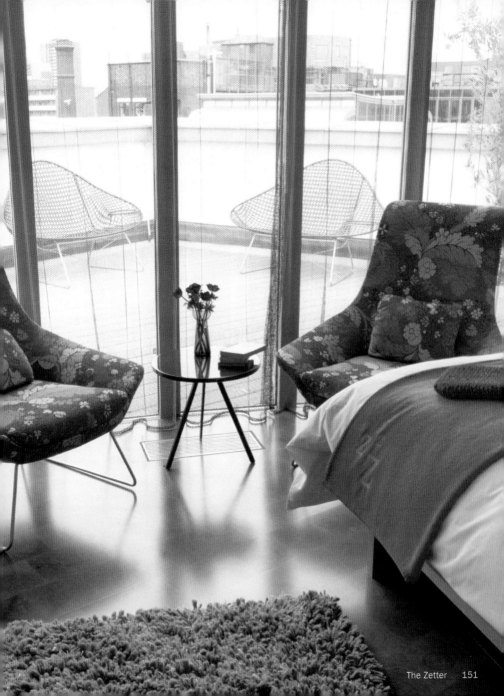

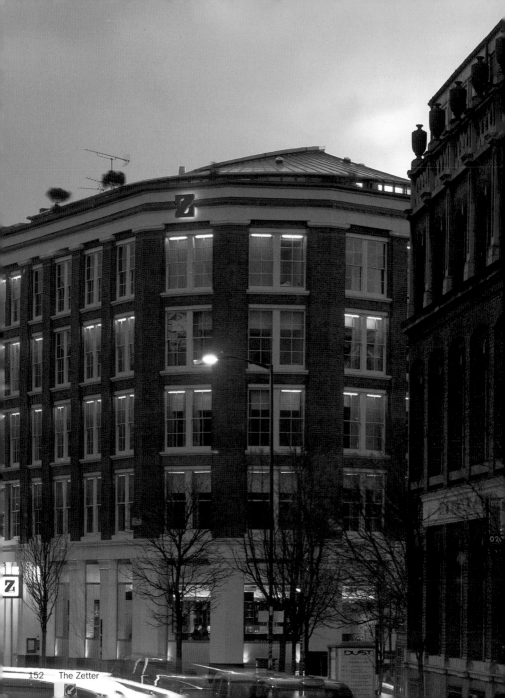

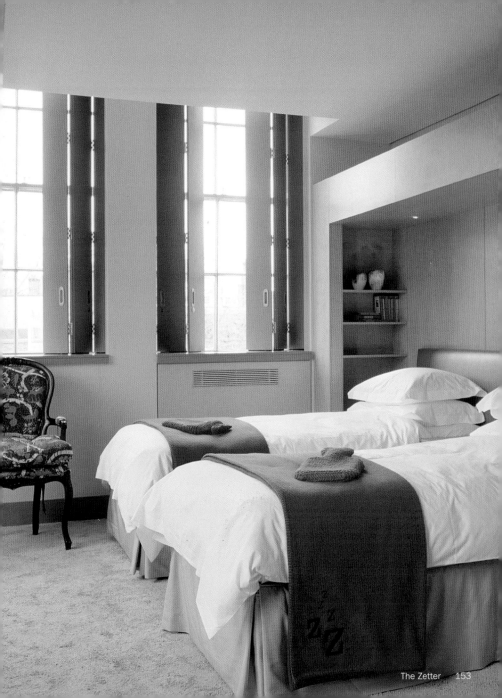

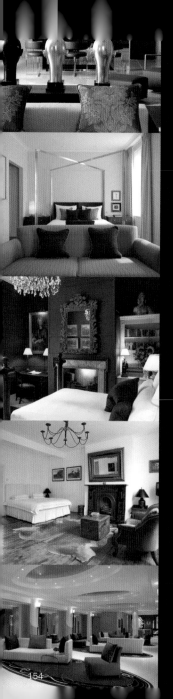

No.	Hotel	Page
1	Baglioni Hotel London	10
2	base2stay	16
3	B+B Belgravia	20
4	The Bentley Kempinski	26
5	The Berkeley	32
6	Bingham	38
7	Blakes London	42
8	Brown's Hotel	48
9	Cadogan London	54
10	The Caesar	58
11	Charlotte Street	62
12	Claridge's	68
13	Courthouse Hotel Kempinski	76
14	Durley House	80
15	Four Seasons Hotel Canary Wharf	84
16	Hazlitt's	88
17	High Road House	92
18	Kensington Rooms	96
19	Knightsbridge Hotel	100
20	The Main House	104
21	Malmaison London	108
22	The May Fair	112
23	Metropolitan London	118
24	One Aldwych	122
25	Park Plaza Sherlock Holmes	126
26	The Portobello Hotel	130
27	The Rockwell	134
28	The Rookery	140
29	Threadneedles	144
30	The Zetter	148

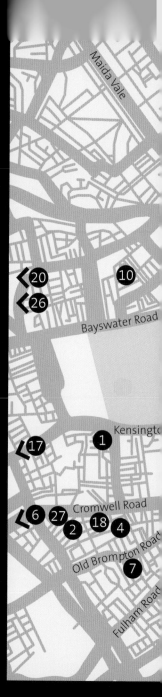

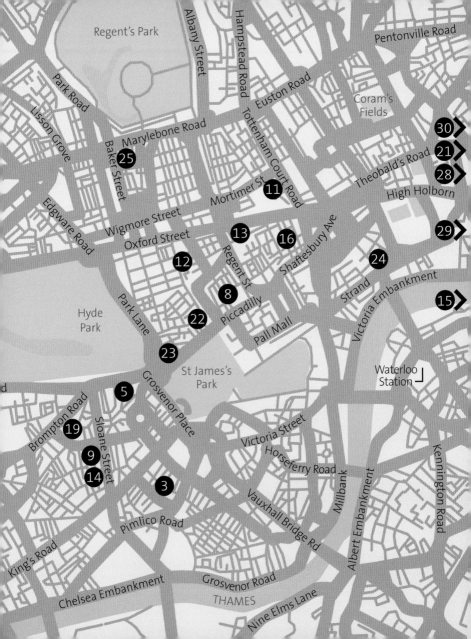

- 43 South Molton | 43 South Molton Street | Mayfair | Phone: +44 20 7647 4343
www.43southmolton.com
- Automat | 33 Dover Street | Mayfair | Phone: +44 20 7499 3033 | www.automat-london.com
- Axis | 1 Aldwych | Covent Garden | Phone: +44 20 7300 0300 | www.onealdwych.com
- Bam-Bou | 1 Percy Street | Fitzrovia | Phone: +44 20 7323 9130 | www.bam-bou.co.uk
- Boxwood Café | Wilton Place | Knightsbridge | Phone: +44 20 7235 1010 | www.gordonramsay.com
- Criterion Grill | 224 Piccadilly | Mayfair | Phone: +44 20 7930 0488 | www.whitestarline.org.uk
- Fifteen | 15 Westland Place | Islington | Phone: +44 870 787 1515 | 0871 330 1515
www.fifteenrestaurant.com
- Fifth Floor | Harvey Nichols, 109–125 Knightsbridge | Knightsbridge | Phone: +44 20 7235 5250
www.harveynichols.com
- Fish! | Cathedral Street, Borough Market | Southwark | Phone: +44 20 7407 3803
www.fishdiner.co.uk
- Hakkasan | 8 Hanway Place | Bloomsbury | Phone: +44 20 7927 7000
- Mo*vida | 8–9 Argyll Street | Soho | Phone: +44 20 7734 5776 | www.movida-club.com
- Moro | 34–36 Exmouth Market | Finsbury | Phone: +44 20 7833 8336 | www.moro.co.uk
- Nicole's | 158 New Bond Street | Mayfair | Phone: +44 20 7499 8408 | www.nicolefarhi.com
- Nobu Berkeley | 15 Berkeley Street | Mayfair | Phone: +44 20 7290 9222
www.noburestaurants.com
- Pétrus | Wilton Place | Belgravia | Phone: +44 20 7235 1200 | www.gordonramsay.com
- Plateau | 4th Floor, Canada Place | Canary Wharf | Phone: +44 20 7715 7100 | www.conran.com
- Salt Yard | 54 Goodge Street | Camden | Phone: +44 20 7637 0657 | www.saltyard.co.uk
- Sketch | 9 Conduit Street | Mayfair | Phone: +44 870 777 4488 | www.sketch.uk.com
- The Admiral Codrington | 17 Mossop Street | Chelsea | Phone: +44 20 7581 0005
www.theadmiralcodrington.co.uk
- The Glasshouse | 14 Station Parade | Kew | Phone: +44 20 8940 6777
www.glasshouserestaurant.co.uk
- The River Café | Thames Wharf, Rainville Road | Hammersmith | Phone: +44 20 7386 4200
www.rivercafe.co.uk
- The Zetter Restaurant | St John's Square, 86–88 Clerkenwell Road | Clerkenwell
Phone: +44 20 7324 4455 | www.thezetter.com
- Tom's Delicatessen | 226 Westbourne Grove | Notting Hill | Phone: +44 20 7221 8818
- Umu | 14–16 Bruton Place | Mayfair | Phone: +44 20 7499 8881 | www.umurestaurant.com
- Yauatcha | 15–17 Broadwick Street | Soho | Phone: +44 20 7494 8888